SIMPLY PAINTING

ACRYLICS

FRANK CLARKE

Published by

Osin ART GALLERY

First Published February 1995, Oisin Art Gallery
44 Westland Row, Dublin 2, Ireland.

Text and Drawings © Frank Clarke
Jacket Design © Oisin Art Gallery
Layout and Design by R. McNeela and D. McNeela
Co-ordination and Distribution by Oisin Art Gallery
Photography by Stephen Travers
Colour Reproduction and Typesetting by Typeform Repro Ltd.
Printed in Ireland by Smurfit Web Press Ltd.

Paperback ISBN 0 9512510 5 8

British Library Cataloguing in Publication Data. A catalogue record for this book is available from the British Library.

The colours recommended for all the paintings in this book are the colours actually used, but due to limitations in the printing process, there may be some variation between the printed colours and your painted colours.

All sizes are approximate.

Dedication

To all those who have a wish to share this wonderful hobby.

Appreciation

To Peg for allowing me to wander all over the world trying to spread the gospel of painting and for always supporting me - she never complained. I know what they mean when they say, "a man is only as good as the woman behind him". What a wife!

To Jimmy, Donal and Rory, and all my friends at Wealdstone and Piscataway. To everyone in television on both sides of the Atlantic and a special thanks to Stephen Travers who rid me of my wrinkles with his camera.

I love you all, you make it great to be alive.

Contents

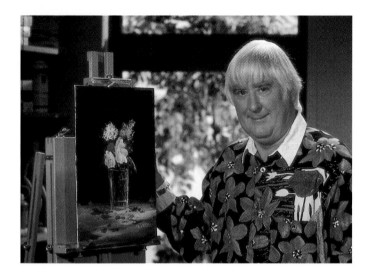

Frank Clarke

Born in Dublin, Ireland, Frank Clarke is a self taught artist who did not begin painting until his thirties. Today he is one of Ireland's best known and sought after artists. Although his pictures may hang in the homes of the rich and famous, he still calls painting his hobby, saying, "a hobby is something you enjoy and painting is my hobby".

Frank developed a unique approach to painting which started him on the road to teaching others. This approach has turned thousands of complete beginners into competent artists in a matter of hours.

Since starting to teach he has made several videos and has had many highly successful television series. He has also made countless radio and television guest appearances demonstrating his unique method.

His first book **Simply Painting - Watercolours** became an immediate best-seller and outsold all other painting instruction books combined in Ireland. It has been read and enjoyed by young and old alike. In fact it is often used in schools and colleges as a reference book to get students started. His exciting **Have Some More Fun** attitude has enabled thousands of people to enjoy the great hobby of painting.

What People Say About Simply Painting

"I have wanted to paint for a long time and your book made it possible for me. Thank you for opening this magic door." F.O'D.

"I am quite obsessed and am only a beginner." M.J.G.

"I am seventy seven years of age and, all my life I wanted to paint a picture. Now I am not afraid to start. Thank you for giving me confidence." M.McC.

"Thank you for writing this wonderful book." A.S.

"You make it all so much fun and pleasure – some change from all the intimidating teachers I have been with." C.M.

"Simply Painting and Frank Clarke was the best thing that ever happened to me" B.K.

"Thank you for your inspiring book, and for curing my painting paralysis." J.S.

"I enjoy every moment of it." C.O'C.

"I think Frank is an ideal instructor for both novice and more advanced art aspirants. He has an easy flowing method of getting across his expertise." F.M.

"I am in my mid-80's and have just started to paint, luckily I chose your book and am absolutely delighted with it." C.C.

"What a difference Simply Painting has made in my life." U.M.

"I have just bought your book Simply Painting and am fascinated by its apparent simplicity." C.O.

"I am having great fun painting, thank you very much." M.L.

Introduction

As the name suggests **Simply Painting** is a simple step by step method which is fun to do and can teach **anyone** to paint.

It was developed by Frank Clarke from his need to understand the simple basics of painting, as he found that most books on the subject were away above his head. On discovering that other beginners suffered from the same problem, Frank decided to do something about it and **Simply Painting** was born.

Frank's method has been proven over and over again with the success of his television series, videos, books and at his demonstrations where he shows, to the amazement of all present that people from the audience who had never painted before, could paint a picture.

So believe him when he says anyone can paint. He has never had a failure.

Try it and amaze yourself.

1: Start Painting Now

Little did I think when writing my first book that it would become a best-seller or that my publishers would be saying, "what about a book on painting with acrylics Frank?". So my "hobby gone mad", has now become my life and I love it.

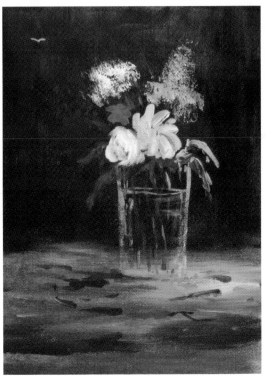

First let me say, I hope you did not expect artistic terminology and theory when you purchased this book. If you did, you will be disappointed.

My sole purpose in writing this book is to get you to START PAINTING and not to give you lessons in theory. As with all professions, artists are very slow to give away the secrets of painting and with good reason - they make their living from painting, so therefore the fewer artists there are, the better. I have often been asked by fellow artists "why are you giving away all the secrets Frank - you will have everybody painting?" My answer is "I hope so".

Painting is without doubt one of the greatest hobbies on earth and everybody can participate, young and old alike. It will give you an insight into nature you never had because, through painting, you will start to look at nature for the first time. It will also help you to appreciate art and how other artists work.

Painting is the most relaxing of hobbies and its therapeutic benefits are enormous. It is also my belief that if the mind is active the body will live longer.

I will ask you to do one thing for me and if you do, I promise you will be painting before you finish this book. Start at page one and follow each exercise. Don't skip to the back of the book - I did not write this book backwards. I am saying this because I am the worst in the world at doing just that and have found to my cost it doesn't work.

What I am going to do is show you how to start, as we all have a natural talent for painting within us, all you need is the urge to paint. Give it a chance and you too can **Have Some More Fun**, **Simply Painting**.

So having said all that don't be afraid, Mr. Brush and myself will show you how to start painting with acrylics.

2: What is Acrylic Paint?

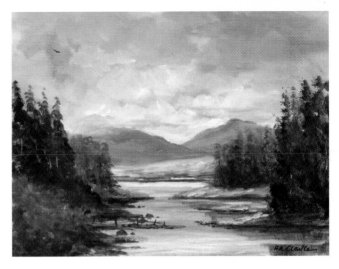

As the purpose of this book is to show you how to paint using acrylic paint, let me first explain what acrylic paint is. It is a synthetic paint which was first used in the 1950's. It is one of the few new artist's paints to be introduced in nearly four hundred years and has many great advantages for the beginner.

Acrylic can be used in the same way as oil paint, but unlike oil paint, it is mixed with water.

Acrylic paint dries very quickly whereas oil paint is very slow to dry. This makes it easy to use because you can paint over your picture in a matter of minutes. You can even correct areas of your painting, let's not call it "correct" let's call it "change", without muddying the picture. You are less likely to get mud using acrylic paints because they dry so quickly.

Acrylic paint has many other practical advantages. It does not use strong smelling solvents and because it mixes with water, it is easy to clean the brushes (provided they are washed immediately after use).

Acrylic paint can be used directly from the tube and there is no need to mix it with mediums. It can also be used on many different surfaces, in fact it seems to bend over backwards to help the artist.

With all these advantages and many more, acrylic paint is in my humble opinion, one of the best paints for beginners.

It is truly the paint of tomorrow.

3: Materials

Paints

Let me tell you a little secret, the major difference between amateur and professional painters is that amateurs use too many different colours, whereas professionals use far less - they mix their own. I use Winsor & Newton Galeria Flow Formula Acrylic Paint.

Here is a list of the colours I use, there are eight.

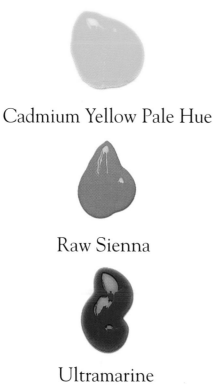

Cadmium Yellow Pale Hue

Burnt Umber

Raw Sienna

Permanent Rose

Ultramarine

Phthalo Green

Vermilion Hue

Titanium White

Using these eight colours you will learn to mix paints to create your own additional colours. For example - yellow and blue will give you green. Permanent Rose and Ultramarine will give you purple.

Don't worry, this will all be explained later in the chapter on colour charts. First let's concentrate on starting to paint.

Tip: Stick with these colours and learn to mix other colours with them. I have selected them because they will give you a wide range of other colours and because they mix well with one another.

Canvas Board

Next we need something on which to paint our picture. An advantage of acrylic paint is that you can paint on most supports. A support is just the surface you paint on. For example it could be, stretched canvas, canvas board, paper, hardboard, glass, metal, or in fact, most oil free surfaces.

For the lessons in this book we are going to paint on Winsor canvas boards, size 14" x 10" (35.5cm x 24.5cm). These are stiff boards made of compressed cardboard and have a primed canvas surface on one side.

There are two reasons for using them. Firstly canvas boards have a hard backing which makes them easier to paint on. Secondly, they are inexpensive.

You can, if you like, re-use your canvas board, just paint over the first picture with white acrylic paint. This is called priming.

The reason I use the artistic definition of the materials is that when you go to your art store you will know what to ask for.

Brushes

It is my belief that too many brushes, like too many colours, can confuse the budding artist, so let's keep them to a minimum. Therefore, in this case, we need only three - one large, one medium and one small.

The reason for this is that when using acrylic paint you only need water to clean your brushes. This cleaning can be done very quickly when you want to paint with a different colour, so there is no need to have brushes for each colour.

Let's deal with the large brush first. It is the **Simply Painting Large Acrylic Brush** size 1.5" (38mm) with which we paint 95% of all our paintings.

Next we need a medium brush, the **Simply Painting Medium Acrylic Brush,** which we use for most of the detail in our picture.

Finally we need a very small brush, the **Simply Painting Round Acrylic Brush**, which we use for fine detail work.

I have designed these brushes especially for acrylic painting and to reduce the need for too many brushes.

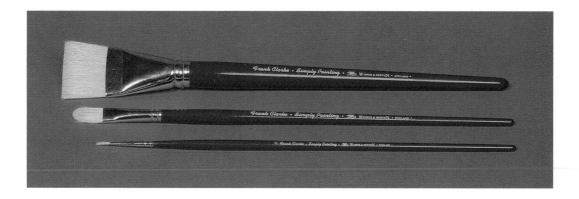

These are all the brushes you need to paint the lessons in this book. They can be obtained in any good art materials or hobby store. Until you acquire the **Simply Painting** brushes, you can use any large and medium flat **bristle** brushes, and any small round nylon brush, so you have no excuse for not starting.

Important: Keep your brushes in water when painting, this will prevent them becoming hard. When finished painting, wash them well in clean water and lay them flat to dry.

If you forget to clean your brushes and they become hard, use a brush cleaner, but don't make a habit of this, as it will ruin your brushes. The best policy is to clean your brushes immediately after every use and they will serve you well.

Easel

It is a good idea to use an easel when painting with acrylic because it is easier when your painting is upright. It allows you to stand back and see what you have done.

It is said that one of the great English landscape painters had a studio forty feet long and after every brush stroke he would run back forty feet from his picture and look at it, to make sure it looked right. This practice can be very helpful if you want to paint and lose weight at the same time.

Anyway back to the easel, there are many kinds, studio easels, box easels, metal easels and table easels.

If you don't want to go to the expense of buying an easel just put your canvas board on the table and raise the back of it about 2" (5cm) off the table. This method is quite adequate and served me well until I was given a present of my first easel.

Tip: A hint around Christmas or your birthday can sometimes produce the desired results, but be sure to explain the type of easel you want.

Palette

A palette is used to mix your paint on and I use the *Simply Painting Acrylic Palette* for this purpose. It is made of plastic and measures approximately 16" x 12" (40.5cm x 30.5cm). The hole is to put your thumb into.

It can be cleaned with water and a paint scraper, palette knife or an old knife.

If you don't have a *Simply Painting Acrylic Palette* you can use an expendable paper (parchment) palette or a large white plate or tray.

Other Materials

Lots of old rags to dry your brushes.
A pencil and a ruler.
An apron or some old clothes.
A container for water.
A hairdryer, if you have one.

Tip: Cut an old large plastic bottle, a water bottle for example, in
half; I find this works very well as a water container.

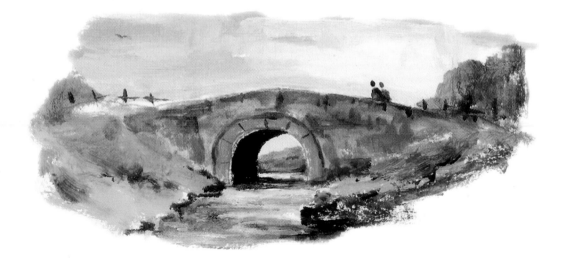

4: Using Water with Acrylic Paint

When painting with acrylic paints I prefer to use the paint directly from the tube and not to dilute it with water. By keeping your brushes in water while painting, they will retain enough water even after you dry them, to make the paint moist.

When applying paint to the canvas board do the following:

1. Take your brush from the water container and dry it on an old cloth. It does not need to be completely dry, just remove the excess water.

2. With the brush still damp, pick up some paint and use it to paint the picture.

3. When you want to change to another colour just dip your brush into the water container and clean it making sure to remove all the paint. Then dry it on your cloth and off you go again.

5: Brush Strokes

Each of the brushes can be used in many ways to produce different strokes. The large *Simply Painting Acrylic Brush*, with which you will paint most of your picture, can be used as follows:

Broad Horizontal Strokes

Broad Vertical Strokes

Narrow Horizontal Strokes

Narrow Vertical Strokes

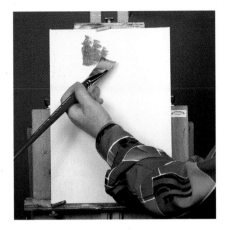

Corner Brush Strokes are painted with the large brush and are very useful for painting trees.

The medium **Simply Painting Acrylic Brush** is used for detail and to finish your clouds. It is great for scumbling the finished clouds. What do I mean by scumbling? Simply moving the brush back and forward using a flat rapid stroke. This leaves a thin layer of colour on the canvas board.

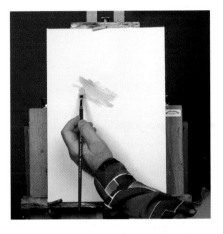

The **Simply Painting Round Acrylic Brush** is used like a pen to draw fine details.

Note: These are just some of the brush strokes you can use. The more you practise the better you will become. Why not try them out for yourself?

6: Have Some More Fun

The hardest thing about painting is knowing how to start. There is no doubt in my mind that we can all paint, but we have two problems stopping us, one is a fear that we don't have the gift and the second is not knowing where to start.

So let's kill these myths. I am continuously confronted by people who say to me, "I would love to paint but I can't draw a straight line". I bet you can draw a straight line if I give you a ruler and a pencil. I bet you can also draw the letter "M" above it. If you don't believe me, why not try it now?

What does it look like? A simple mountain scene. So you see, you have the gift. If you were to sign it and frame it you may even sell it.

Now how do you start? Let me explain the meaning of **Have Some More Fun**. Each of the words has a special meaning when we use the first letter to remind us of the order in which we paint our picture.

Have	=	H	=	Horizon
Some	=	S	=	Sky
More	=	M	=	Middleground
Fun	=	F	=	Foreground

That is how we construct our picture.

Have

First we draw our horizon line, always straight across the board.

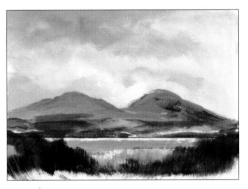

Some

Starting at the top of your picture and keeping above the horizon line paint the sky.

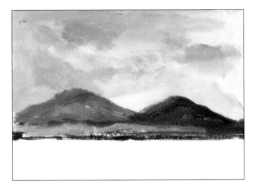

More

Next just above the horizon line paint in a letter "M" to represent the mountains.

Fun

Last we paint the foreground.

To Repeat: Start by drawing the horizon line, that gives you something to build your picture from. Next paint a sky, then a middleground and lastly a foreground. Finally add in some detail. This will all be explained in greater detail when you begin the first lesson.

I'm sure by now you will realise, that by using the **Have Some More Fun** method, you will be able to paint, so let's get to our first lesson.

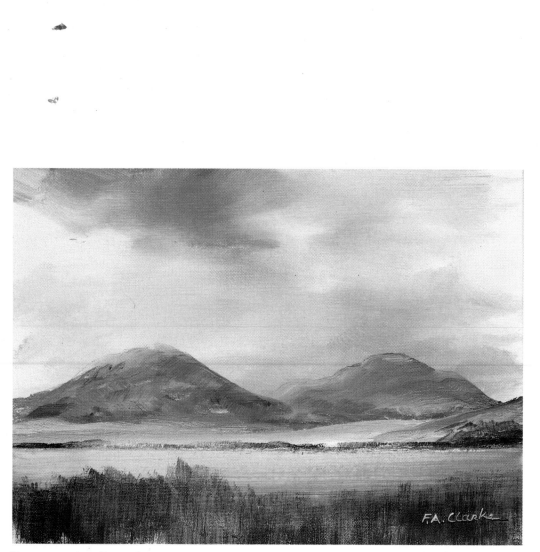

Lesson 1 - Landscape *Finished Painting*

7: Lesson 1
Your First Picture in Acrylics

For your first lesson you will need the following materials:

- 14" x 10" (35.5cm x 24.5cm) Winsor Canvas Board.
- 1.5" (38mm) *Simply Painting* Large Acrylic Brush.
- *Simply Painting* Medium Acrylic Brush.
- *Simply Painting* Round Acrylic Brush.
- *Simply Painting* Palette or a large white plate or tray.
- *Acrylic Paints* - Ultramarine, Raw Sienna, Titanium White.
- Water Container.
- Old Cloths
- A Pencil and a Ruler.
- An easel, if you have one.

So off we go

Tip: It is a good idea to wear a bib or smock if you are sloppy like me, as acrylic paint can stain your clothes. Also read the lesson in full before you start to paint.

Step 1 Have - Horizon

If you have an easel use it to place your 14" x 10" (35.5cm x 24.5cm) Winsor canvas board on. If not, don't worry, just place it on the table in front of you and raise the back approximately 2" to 3" (5cm to 7.5cm), by putting something under the canvas board.

Tip: If you are not using an easel, cover your table with an old cloth or newspaper.

As we are going to paint the first picture in landscape (longways) set it up as below.

Put the three brushes into the water container, make sure there is water in it silly!

Next take the following three tubes of paint and squeeze some of each onto the side of your palette.

Ultramarine

Raw Sienna

Titanium White

Now using the pencil draw the horizon line one quarter of the way up from the bottom of the canvas board. Use a ruler or a straight edge.

You can, if you like, use the small brush to draw the horizon line, but don't forget to put the small brush back into the water. If you don't the paint will dry on it before you use it again.

Tip: Make it a habit to always rinse the brushes in the water after use.

Step 2 Some - Sky

Now take the large brush from the water container and dry it on the cloth. Dip it into the Titanium White paint and add very little Raw Sienna paint.

Starting at the top of your board, paint this mixture down as far as the horizon line, in the same way you would paint a door, using broad horizontal brush strokes. Return your brush to the water.

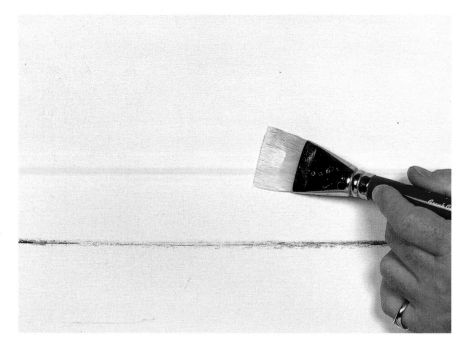

Tip: Before you start to paint the sky refer to the finished painting on page 26 and keep referring to it as you move through the lesson.

While the sky is still wet, take your large brush from the water container and dry it on the cloth. Then using Ultramarine only, start at the top of the board, and paint in some sky.

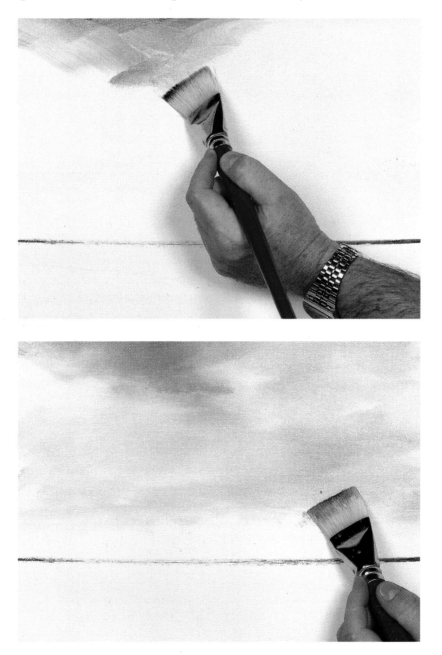

Now let it dry, you can use a hairdryer if you wish. I hope you did not forget to return the brush to the water?

Step 3 More - Middleground

Take the large brush from the water and dry it. Then, using 1/3 Titanium White, 1/3 Raw Sienna and 1/3 Ultramarine, and without mixing the paint too much on the palette, paint the letter "M" (a wobbly one) just above the horizon line. Don't make it too round or too big, look at the finished painting on page 26.

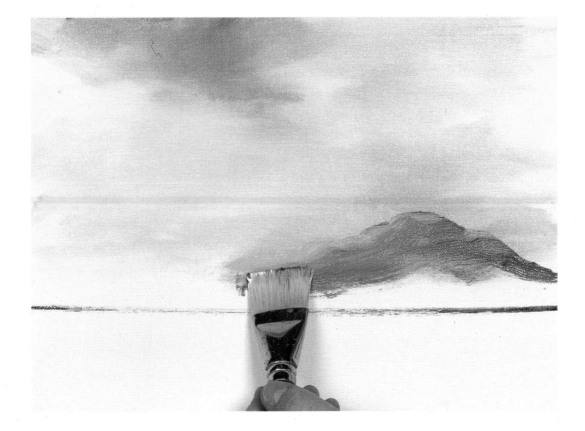

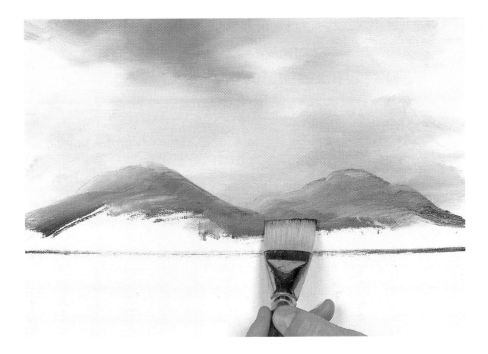

Now fill in the letter "M", still keeping above the horizon line. This gives you the mountains.

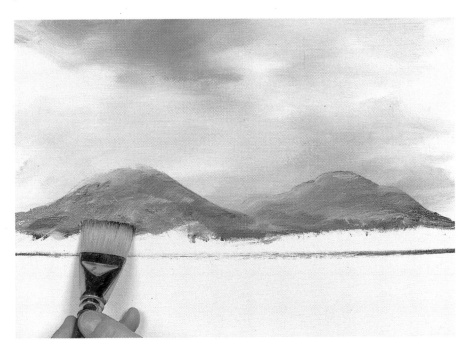

Return your brush to the water and rinse.

Once more dry the large brush and, using Raw Sienna with a little Titanium White, paint the middleground under the mountains, but keeping just on and above the horizon line.

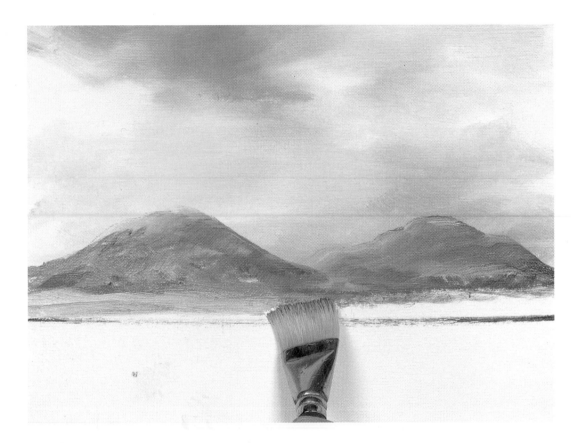

Return the large brush to the water.

Take the large brush from the water and dry it on your cloth. Using 2/3 Ultramarine and 1/3 Raw Sienna, paint in the distant river bank using narrow horizontal strokes (see Brush Strokes page 22), just above the horizon line. Go right across the canvas but be careful not to go below the horizon line.

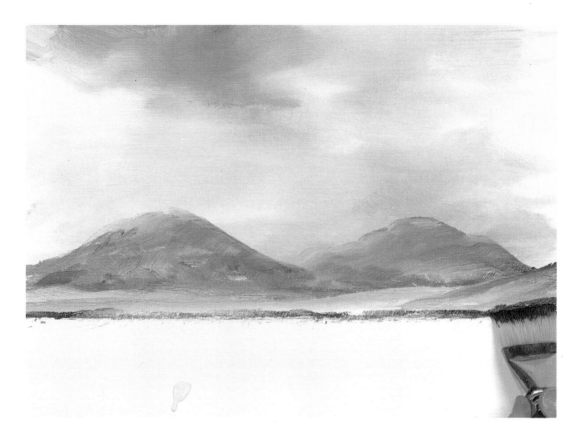

I know by now you must be fed up with my harping on about returning your brush to water, but it will mean your brushes will last longer.

Keep referring to the finished picture on page 26 as you go along.

Tip: Don't mix the paint on your palette too much.

Now we must paint the water. Take the large brush from the water container and dry it. Dip it into the Titanium White and add a little Raw Sienna. Use the same mixture as you used for the sky.

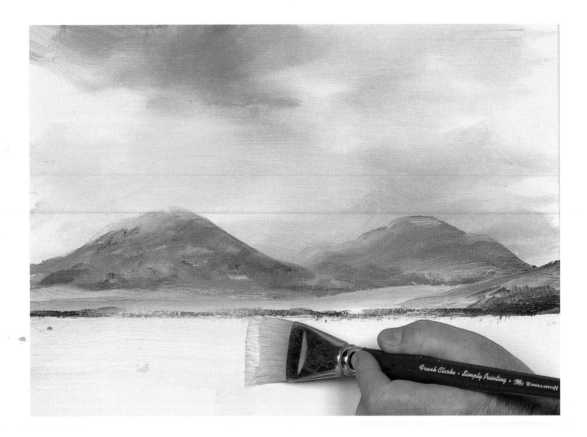

With broad horizontal strokes (see Brush Strokes page 22) draw the brush across the canvas just below the horizon line. Do this in the same way as if you were painting a door and repeat it all the way to the bottom of the canvas board using as much paint and as many strokes as are required.

Tip: Don't be mean with the paint.

Without cleaning the brush, dip into the Ultramarine and repeat this stroke over the Titanium White and Raw Sienna. Do this before the Titanium White and Raw Sienna mixture dries.

Now return your large brush to the water.

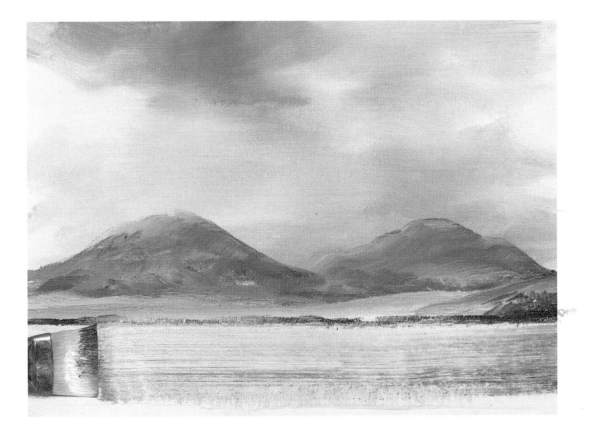

Next let the painting dry. This will take about 5 minutes.

Why not have a cup of coffee and remember you are lucky to be using acrylic paint as oil paint can take months to dry. You should now begin to see the advantages of acrylic paint, in fact you can use your hairdryer to speed the drying process even more if you wish.

Step 4 Fun - Foreground

Next we come to the foreground, which in this case is the rushes (or reeds) at the bottom of the painting. To create rushes, use your large brush with 1/2 Ultramarine and 1/2 Raw Sienna and make broad vertical strokes (see Brush Strokes page 22) all across the canvas board.

Don't make the rushes too even. Use light strokes and don't mix the paint too much on the palette. Let it mix on the canvas board.

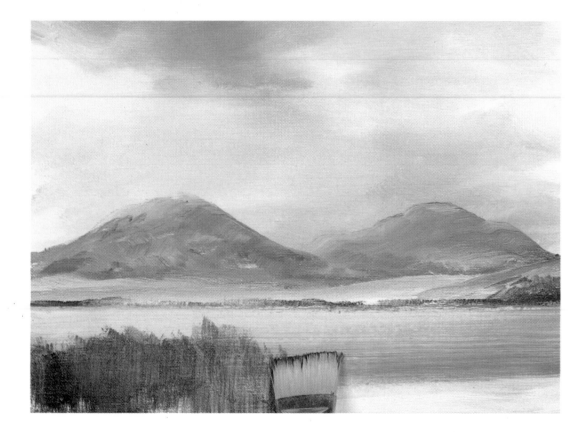

Return your large brush to the water and clean it.

Take out the small brush. Using Ultramarine with lots of water make your paint the consistency of ink. Draw a flat letter "V" in the sky and you have a bird.

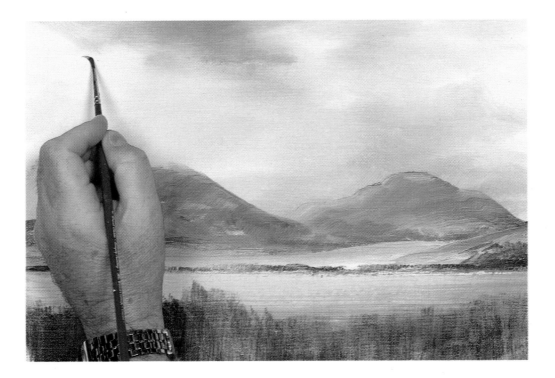

Now sign it.

Congratulations!

You have just completed your first acrylic picture using the *Simply Painting*, *Have Some More Fun* method.

Tip: Now wash and clean your brushes and leave them flat to dry.

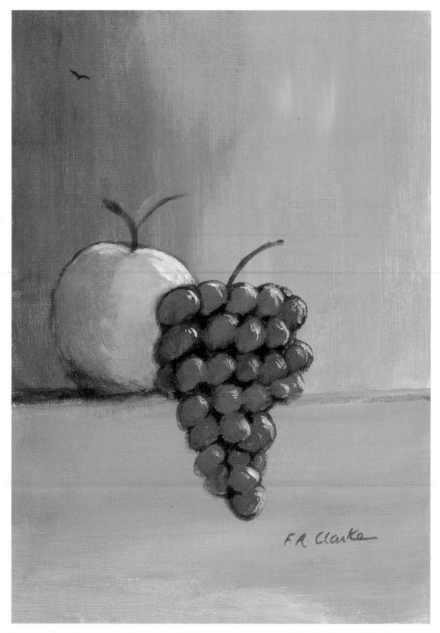

Lesson 2 - Apple and Grapes *Finished Painting*

8: Lesson 2
Apple and Grapes

For your second lesson you will need following materials:

- 14" x 10" (35.5cm x 24.5cm) Winsor Canvas Board.

- 1.5" (38mm) *Simply Painting* Large Acrylic Brush.

- *Simply Painting* Medium Acrylic Brush.

- *Simply Painting* Round Acrylic Brush.

- *Simply Painting* Palette or a large white plate or tray.

- *Acrylic Paints* - Ultramarine, Permanent Rose, Phthalo Green, Cadmium Yellow Pale Hue, Burnt Umber, Titanium White.

- Water Container.

- Old Cloths.

- A Pencil and a Ruler.

- An easel, if you have one.

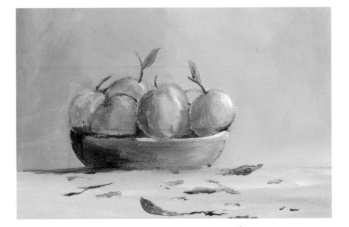

Please read the lesson completely before you start to paint.

For our second lesson we need to think shapes. Let me explain. I bet you will find it easier to draw a circle than an apple. The same goes for grapes. Let's try it on a piece of paper with your pencil.

First draw a circle freehand.

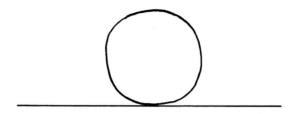

Now by adding a stalk and a leaf, we can turn our circle into an apple.

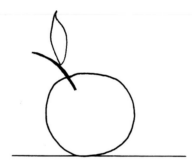

For the grapes we need two shapes. First a triangle, which is once again drawn freehand.

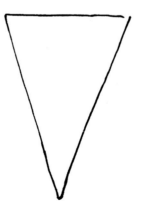

Next fill the triangle with circles. It does not matter if the circles overlap. Add the stalk and we have a bunch of grapes.

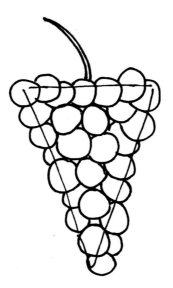

These are the two basic shapes we need for this lesson. It's easy when you think shapes isn't it?

Now we are ready to start painting our second lesson.

Tip: When drawing the grapes you don't have to remain within the triangle, let them flow on and outside it.

Step 1 Have - Horizon

As in the first lesson if you have an easel use it, if not place your 14" x 10" (35.5cm x 24.5cm) Winsor canvas board on a table in front of you and raise the back about 2" (5cm) off the table.

Our second lesson is painted in portrait fashion (upright) so set it up as follows:

Next take the tube of Ultramarine and squeeze some onto the edge of your palette.

Put the three brushes into the water.

Now using the small brush with a ruler or straight edge, take some Ultramarine and draw a horizon line approximately 1/3 up from the bottom of the board. You can use the pencil to draw the horizon line if you prefer.

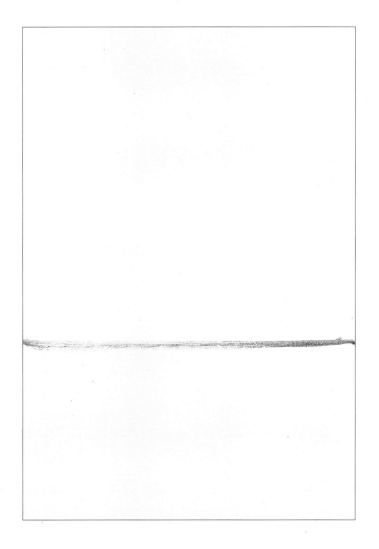

Don't forget to return the brush to the water and rinse it.

Step 2 Some - Sky

Now squeeze some Permanent Rose, Cadmium Yellow Pale Hue and Burnt Umber onto the palette. Keep to the side of the palette and don't be mean with the paint. Take the large brush from the water container and dry it on your cloth.

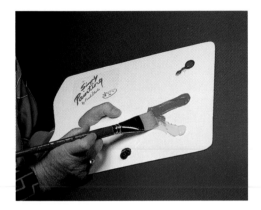

Now bring some Cadmium Yellow Pale Hue and some Permanent Rose into the centre of the palette. About equal amounts of each will do.

Starting from the top of the board and using the large brush, paint the sky, which on this occasion is the background, down to the horizon line. Use broad vertical strokes (see Brush Strokes page 22).

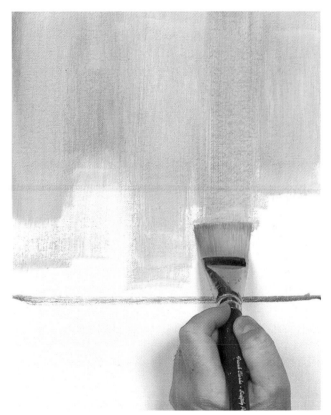

On the left hand side of the canvas board, using the large brush with a mixture of 1/2 Permanent Rose and 1/2 Burnt Umber, paint a darker area from the top of the board down to the horizon line.

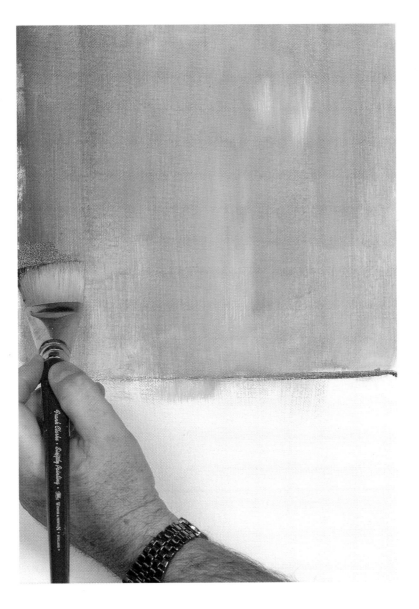

Return your brush to the water and rinse it.

Now on and below the horizon line, with a mixture of 1/2 Permanent Rose and 1/2 Cadmium Yellow Pale Hue, paint down to the bottom of the canvas board. This time, paint using broad horizontal strokes (see Brush Strokes page 22), the same as you did for the water in Lesson 1.

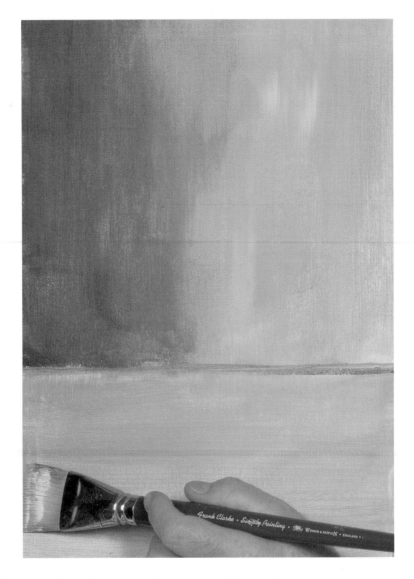

When finished, replace the large brush in the water container and let the painting dry. Refer to the finished painting on page 40.

Tip: You can, if you like, dry your painting with a hairdryer, I do.

Next we draw our shapes. First we begin with the big circle (apple) and paint it on and above the horizon line. Using the small brush with some Burnt Umber paint, draw a circle above the horizon line, about 2" (5cm) in from the left edge of the board. Remember think shapes, not apples. Look at the finished picture on page 40.

Now we come to the triangle (grapes), once more starting above the horizon line draw a triangle. Draw it freehand and overlap the circle (apple) a little with the triangle.

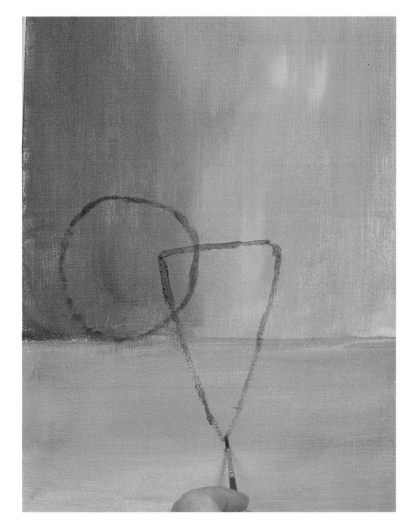

Tip: If you prefer, use a pencil to draw the circle and triangle, you may find it easier.

When you have completed the triangle fill it with small circles letting them overlap. You can go outside the triangle.

Now add your stalks using Burnt Umber paint and the small brush.

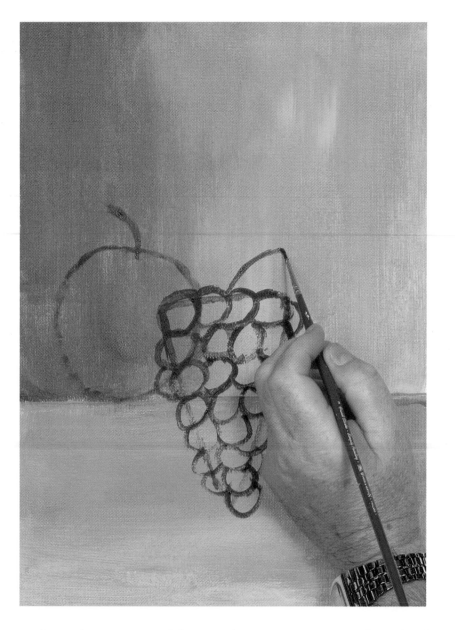

And you thought you could not draw! Have another look at the finished painting on page 40.

Step 3 More - Middleground

Now let's paint the circle and triangle or should I now say the apple and grapes. Paint the apple first, using the medium brush. Squeeze some Phthalo Green and Titanium White onto your palette, keeping them to the side.

Mixing 3/5 Cadmium Yellow Pale Hue with 1/5 Phthalo Green and 1/5 Titanium White will give us a pale green.

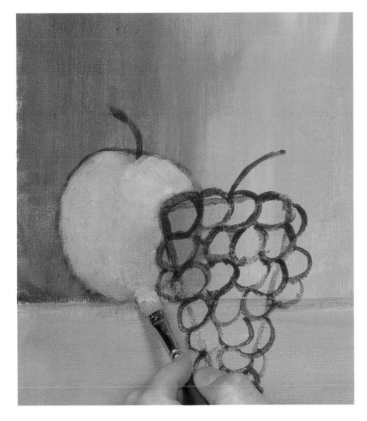

With this mixture paint the apple pale green. It may be necessary to give it a second coat after it has dried.

Tip: You can adjust the colour of the apple by adding more yellow and white to lighten it and more green to darken it.

Return your brush to the water and rinse it.

Next we come to the grapes which in this case, are black grapes. To get the required colour we need to mix 1/4 Permanent Rose with 3/4 Ultramarine and add a little Titanium White.

Now paint in the grapes using circular strokes with the medium brush. Return the brush to the water when finished.

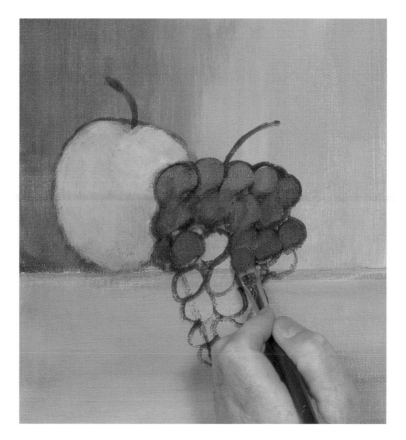

Mix some Burnt Umber with some Ultramarine about half of each will do. Using the small brush paint between the grapes. This will give you dark areas which will show up the grapes. You may need to add a little extra water to get the paint to flow easier.

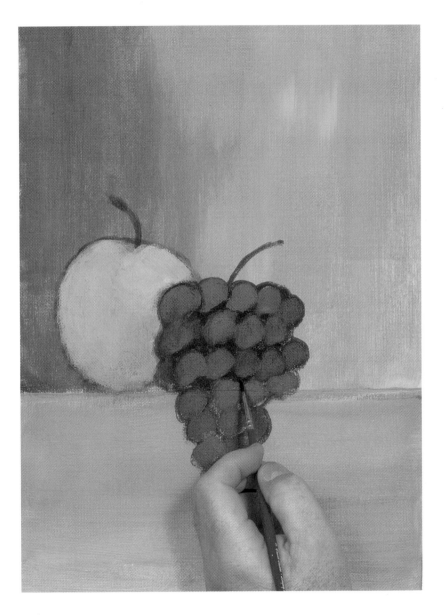

Clean and dry your brush.

Now using Titanium White paint only, with your small brush, paint some highlights on your grapes. Keep the highlights on the right hand side of each grape, as this is where the light is coming from in the picture.

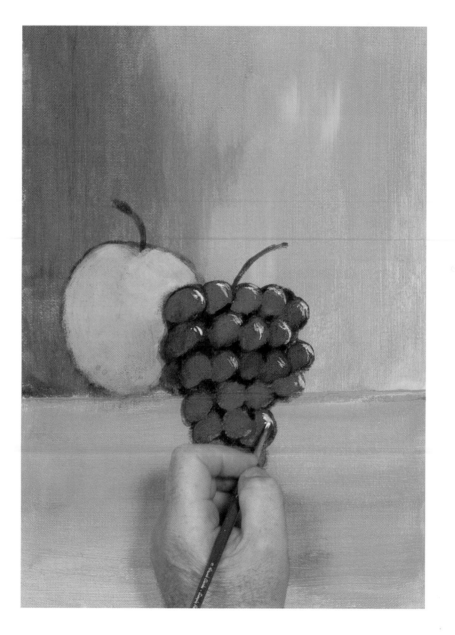

Return your brush to the water.

Now back to the apple. Let's put some red on the apple using a little Permanent Rose. With your medium brush, paint some Permanent Rose on the left hand side of the apple. Paint it in a curve as if painting a real round apple.

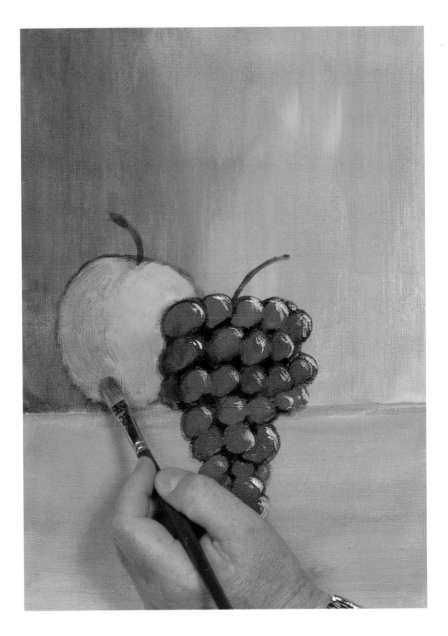

Rinse your brush and return it to the water.

Look again at the finished painting. We must now paint the leaf of the apple using the small brush with a mixture of 1/2 Cadmium Yellow Pale Hue and 1/2 Phthalo Green.

Then shade the lower side of the leaf using Phthalo Green only.

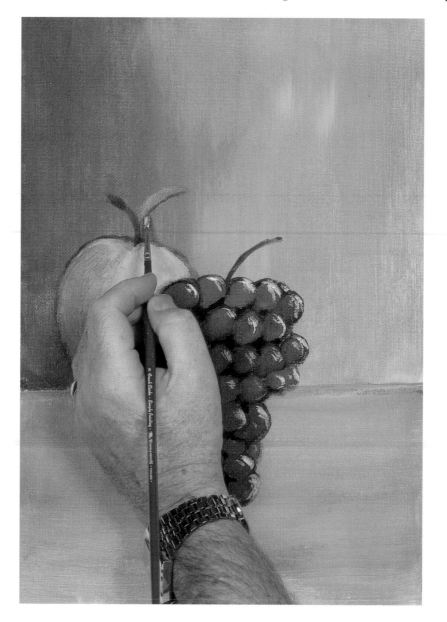

Rinse your small brush in the water.

On the right hand side of the apple, using mostly Titanium White with a little Cadmium Yellow Pale Hue, paint some highlights with the small brush.

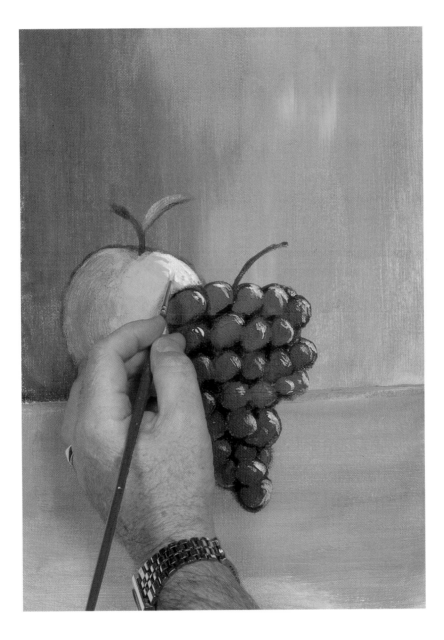

Return your brush to the water.

To finish, using the medium sized brush with some Burnt Umber, paint a shadow on and under the left side of the apple.

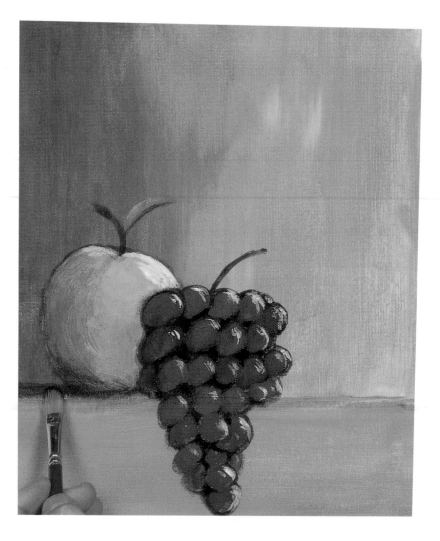

Now wash and clean your brush.

Step 4 Fun - Foreground

All we have in the foreground of this picture is our signature. So sign it, and leave it alone.

With acrylic paint you can paint over the picture as often as you like. This can be a blessing but it can also be a curse. Because it is so easy to repair mistakes or change your painting, there is a temptation to keep fiddling with the picture. In fact I once met a student who was painting the one picture for months. She probably ruined at least fifty good pictures by fiddling.

If you think you are the only one who keeps fiddling with your pictures, I can tell you one of the hardest things about painting is knowing where to start and when to stop. Beginners have the bad habit of continuing to paint because they have some paint left on their palette.

My advice is, sign it and leave it alone! I have many students who finished their painting in my class, took it home, started to repaint it and then returned to the next class with the picture ruined.

SO SIGN IT AND LEAVE IT ALONE - DON'T FIDDLE!

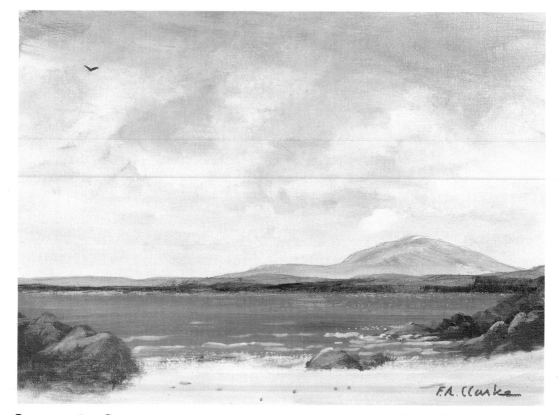

Lesson 3 - Seascape **Finished Painting**

9: Lesson 3 Seascape

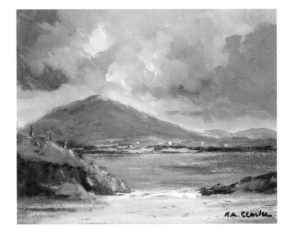

For this lesson you will need:

- 14" x 10" (35.5cm x 24.5cm) Winsor Canvas Board.

- 1.5" (38mm) *Simply Painting* Large Acrylic Brush.

- *Simply Painting* Medium Acrylic Brush.

- *Simply Painting* Round Acrylic Brush.

- *Simply Painting* Palette or a large white plate or tray.

- *Acrylic Paints* - Ultramarine, Raw Sienna, Titanium White, Phthalo Green, Cadmium Yellow Pale Hue, Burnt Umber.

- Water Container.

- Old Cloths.

- A Pencil and a Ruler.

- An easel, if you have one.

Off we go again

Don't forget to read the lesson completely before you start.

Step 1 Have - Horizon

Take the 14" x 10" (35.5cm x 24.5cm) Winsor canvas board and place it on the table in front of you. Raise the back approximately 2" to 3" (5 to 7.5cm) by putting something under the canvas board or use your easel if you have one.

We are going to paint in a landscape fashion, longways, the same as we did in the first lesson.

Put the three brushes into the water.

Squeeze out some Ultramarine, Raw Sienna and Titanium White onto the side of your palette.

Next using your small brush take some Ultramarine and draw the horizon line approximately 1/3 of the way up from the bottom of the canvas board. Use a ruler if you have one.

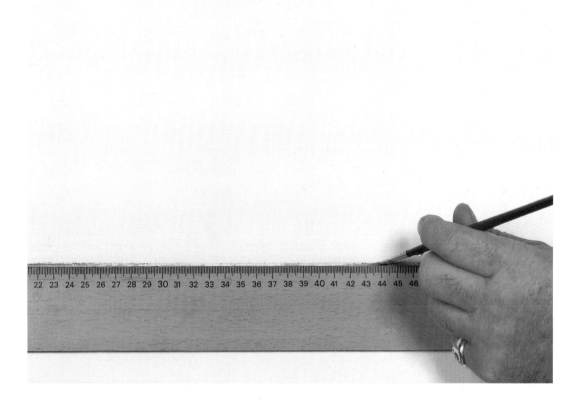

Now put the small brush back into the water or the paint will dry on it. You can use the pencil to draw the horizon line if you prefer.

Step 2 Some - Sky

Take the large brush from the water container and dry it on the cloth. Bring some Titanium White paint into the centre of the palette and add some Raw Sienna to it. The mixture should be 2/3 Titanium White and 1/3 Raw Sienna.

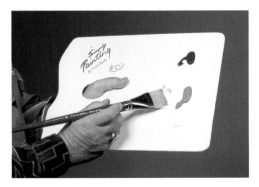

Starting from the top of the board paint this mixture down to the horizon line. Don't go below the horizon line.

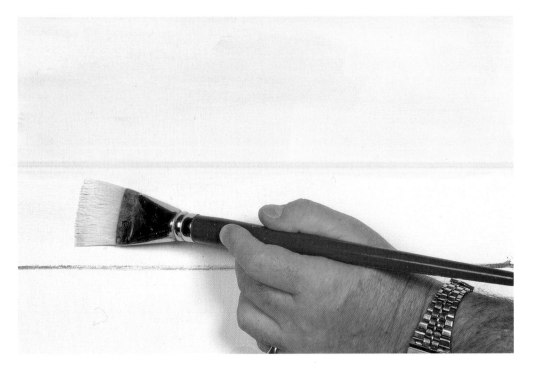

Clean your brush and dry it.

While the paint is still wet on the canvas board, paint in some sky using Ultramarine. Once more start at the top of the board and work downward.

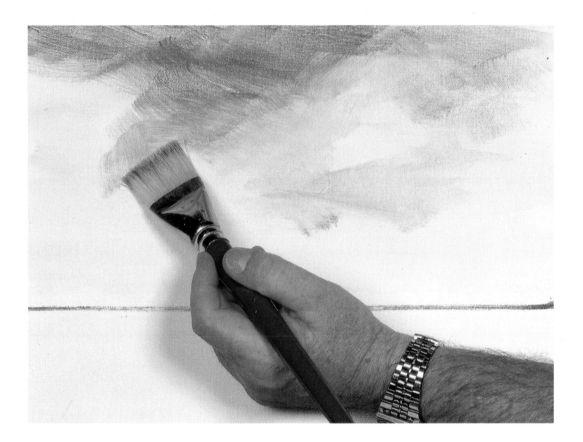

When finished put the brush back into the water.

Using only Titanium White on the large brush, outline some cloud areas. This completes the sky.

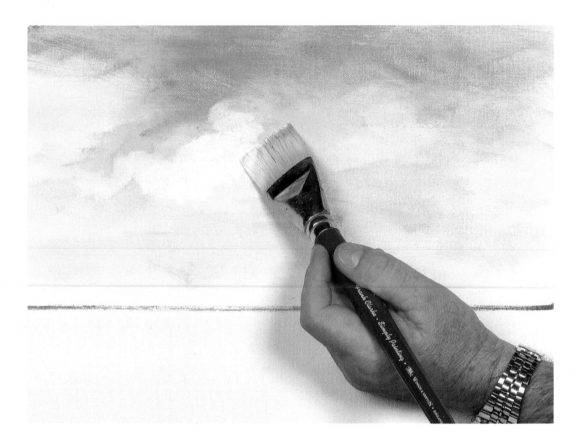

Return your brush to the water container.

Tip: If you want to soften the sky area take the large brush from the water and dry it. Then very lightly, starting from the top of the picture draw it across the sky using broad horizontal brush strokes (see Brush Strokes page 22). This must be done while the paint on the board is still wet. Once is enough to do this or you will smudge your picture.

Step 3 More - Middleground

Once more take the large brush from the water and dry it. Using equal amounts of Ultramarine, Raw Sienna, and Titanium White, paint the mountains. In this case they are a long flat letter "M" and are of course, above the horizon line.

Don't mix your paint too much on the palette, let the brush mix it on the board. This will give shaded effects and avoid flat looking mountains. Now don't panic, it will get easier with a little practice.

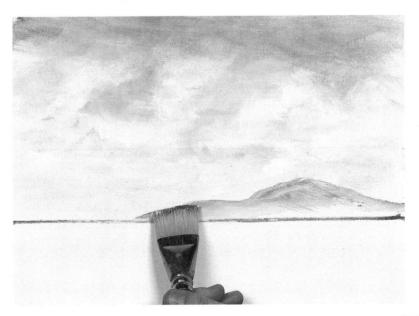

Don't forget to refer to the finished picture at the start of the lesson.

The next part of the middleground is the distant shore. For this we need some extra colours, Cadmium Yellow Pale Hue and Burnt Umber. So put these colours out on your palette, keeping them to the side of it.

Then with the large brush, take a mixture of 2/3 Cadmium Yellow Pale Hue and 1/3 Raw Sienna and a little Ultramarine.

Paint in the distant middleground. Remember to keep above the horizon line and not to mix the paint too much on the palette.

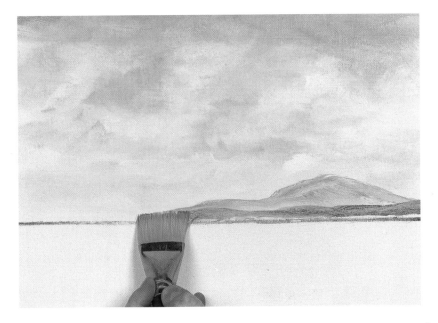

Now without cleaning the large brush take some Burnt Umber and using narrow horizontal strokes (see Brush Strokes page 22) paint right across the canvas board on the horizon line.

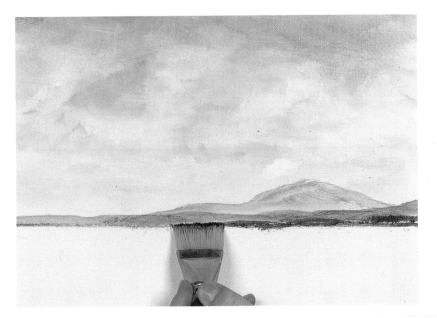

Return the large brush to the water.

Next comes the sea. Once more remove the large brush from the water and dry it on the cloth. With a mixture of 2/3 Ultramarine and 1/3 Titanium White, and using broad horizontal brush strokes (see Brush Strokes page 22), paint in the sea.

It may be necessary to repeat this several times across the canvas board. Leave about 2" (5cm) at the bottom of the painting for the beach. Look at the finished picture. Don't worry about the headland on the right side of the picture, we can paint that when the sea is dry.

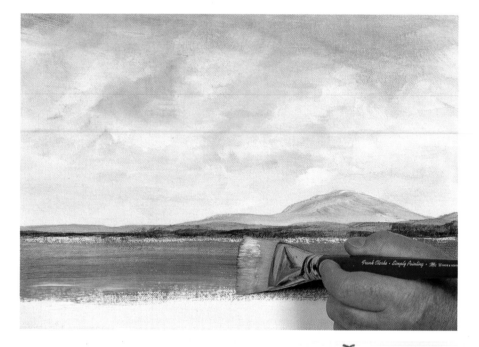

Return the brush to the water and let the picture dry.

Use your hairdryer if you have one.

When the painting is dry, we can paint the headland on the right hand side of the picture.

Take the medium brush from the water and dry it. Then with a mixture of 1/3 Raw Sienna, 1/3 Cadmium Yellow Pale Hue and 1/3 Burnt Umber, paint in the headland.

Start from the top of the headland and remember not to mix the paint too much on the palette.

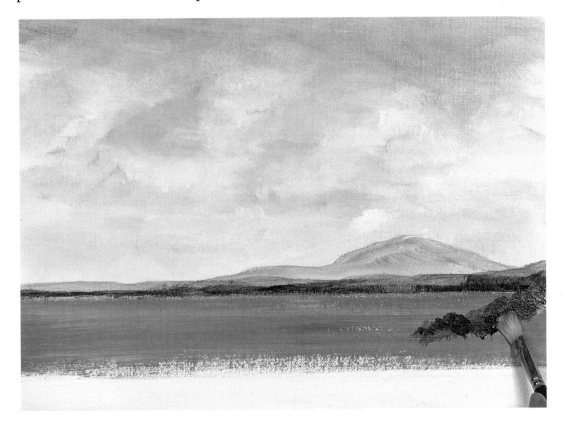

Remember to keep referring to the finished painting.

Step 4 Fun - Foreground

Next we come to the beach and this is painted with 1/3 Raw Sienna and 2/3 Titanium White. Use the large brush, which you once more remove from the water and dry.

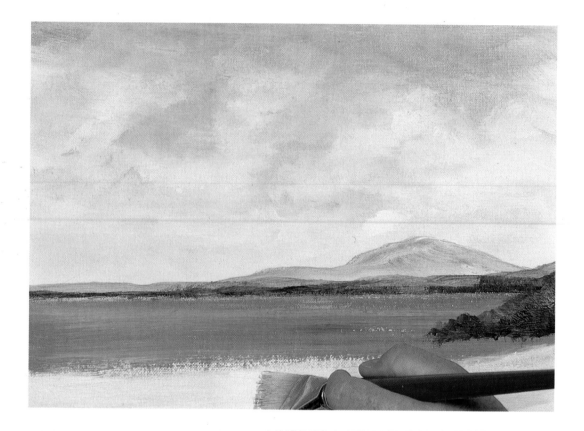

Paint the beach in a curve from the bottom of the headland on the right hand side, all the way across to the left hand side of the picture.

Return your brush to the water and rinse.

Now let's paint the rocks with the medium brush. Make a mixture of Raw Sienna and Ultramarine, 1/2 of each, and paint the rocks. Start with the ones around the headland on the right hand side.

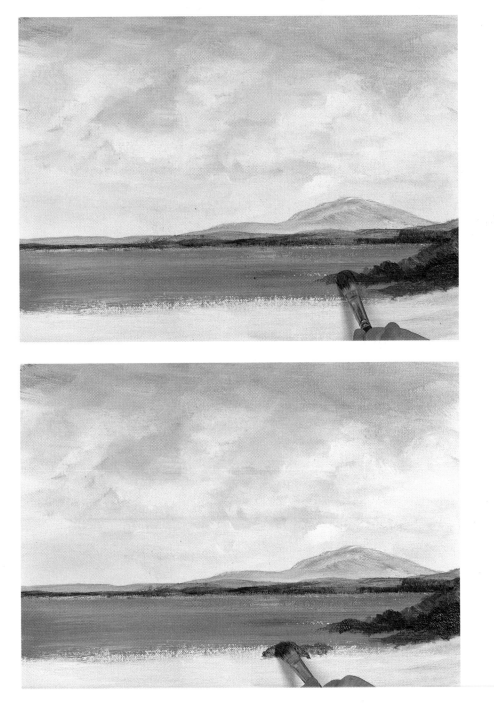

Now while the rocks are still wet, use the medium brush to add some highlights to the rocks in the foreground. Use Titanium White only and remember the light is coming from the left hand side of the picture so the highlights will be on the left hand side of the rocks.

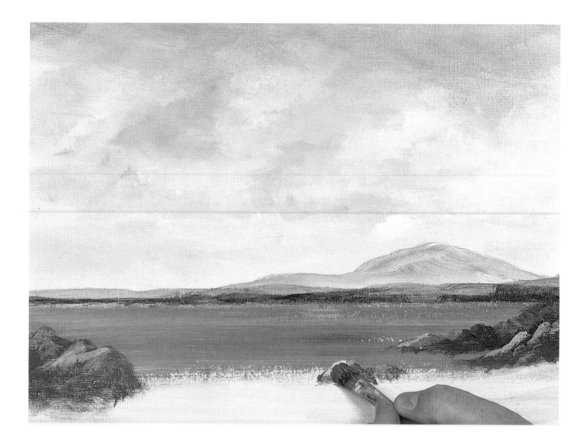

Return your brush to the water.

Now, with the small brush, let's paint some waves using Titanium White.

We can also add some stones in the foreground using Burnt Umber and the small brush.

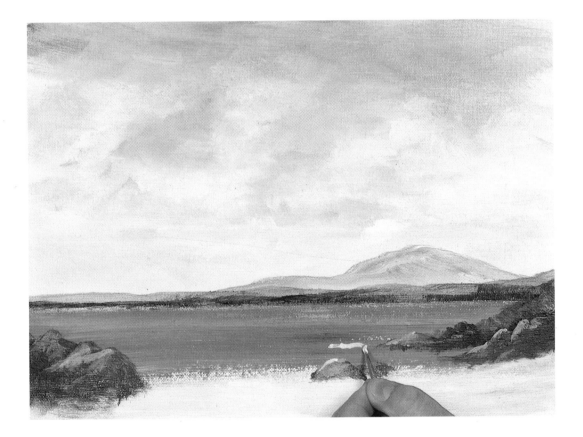

Lastly, why not put in some letter "V's" or birds?

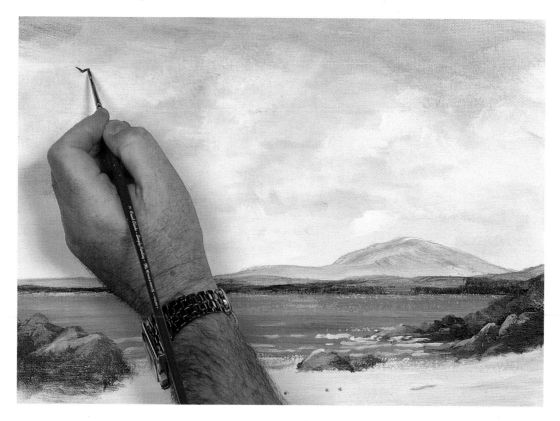

Now sign it

Well Done !

10: Figures in Landscapes

It is very difficult to paint figures, or is it? Well I was given to believe it was and so were most amateur painters. This is borne out by the fact that if you go to any amateur art exhibition you will be amazed by the lack of figures in landscape paintings, even in street scenes - midday in New York and not a person in sight! This is because they were told figures are difficult to paint and so they develop a fear of figures.

I say **FIGURES ARE EASY** - if you do them my way. Let's try it.

Firstly, I want you to forget figures and think carrots. Imagine you are in your local vegetable store and have a carrot in your hand. Now take your small brush and paint six carrots for me. Use Burnt Umber and add a little extra water to help the paint flow.

REMEMBER - THINK CARROTS.

Now paint six dots just above the carrots. Don't make the dots too big and don't allow them to touch the carrots.

Voila! - People

So you see, it is not necessary for figures in landscapes to have legs, arms, hands or noses. They can be just impressions of people. If you don't believe me next time you are in an art gallery look at the figures in landscape paintings.

We can now expand these carrot figures further. Let me show you how to draw or paint male, female and baby carrots. If you take another look at your carrot figures they probably look like male carrots, so how do we draw a female carrot?

Once again draw or paint two carrots. Put a dot above one of the carrots as before. On the other carrot however, place the dot so that it is joined to the body.

So you see while the male carrot's head is separated from his body, the female carrot's head is well connected to her body - as you ladies know only too well.

How about baby carrots? A baby carrot's head is almost the same size as a fully grown carrot but its body is smaller. Let's draw some families.

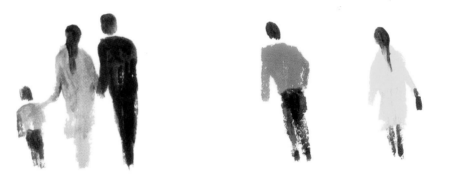

If you spend ten minutes practising carrot people you will become an expert and will not have any fear of putting life-like figures into your paintings. All the shapes are drawn freehand with a pencil or the small paint brush. Don't make them too perfect.

And you thought figures were difficult.

To Recap

1. Think carrots.
2. Draw them freehand.
3. Don't make the heads too big
4. The head of a baby carrot is almost as big as that of a full sized carrot, but its body is smaller.
5. Practice makes perfect - keep practicing carrots and you will get better every time.

11: Flowers

Flowers are another subject which can be painted easily using simple shapes. We begin by drawing a circle for the centre of the flower. Then draw six more circles to go around the centre circle.

Finally draw a stem and a leaf.

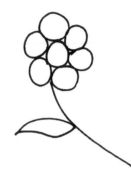

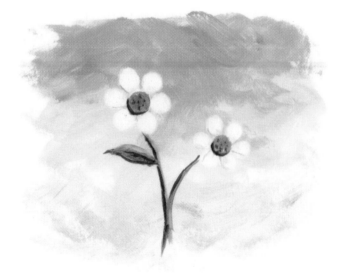

Now let's paint a vase to put our flowers in so back to shapes.

First, draw or paint a circle just like the letter "O".

Now on the top of the circle draw a box.

Now draw or paint a straight line under the circle just touching it, and there is your vase.

Why not paint a vase of flowers using these shapes? Note the shadow and highlights on the vase and remember to put in your Horizon line first and then paint your background, as you did in Lesson 2. Try out some new colours of your own.

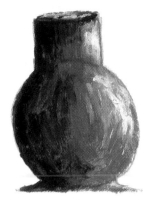

12: Boats, Cottages, Bridges

Again using simple shapes, let's paint a boat. Start by drawing or painting a rectangle.

Next, at each end of the rectangle, add a triangle as in the picture below.

We now have a simple boat. If we add two half carrots to the scene we have figures in the boat.

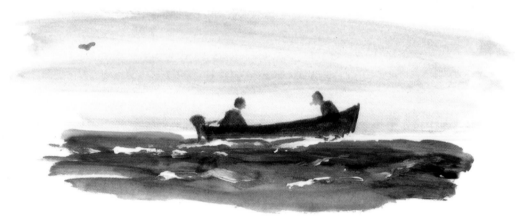

Tip: Don't put the figures in the centre of the boat. Put them towards the front and the back and your picture will look better.

How about a different boat? Once again back to shapes. Draw the number eight on its side making it flat.

Now in the centre of the front part of the eight, draw a vertical straight line.

Now join the back to the front using a curved line.

And lastly, join the front part of the eight to the bottom of the first vertical line you drew.

You have a boat once again. Try this out a few times.

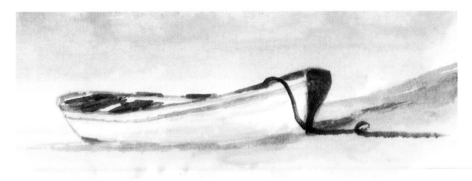

Cottages

One of the great advantages of using acrylic paints is that you can add to your painting at any time. This means you can paint your background first and then paint the buildings later.

Let's try it. So first paint the background. Use Titanium White and a little Ultramarine for the sky and Cadmium Yellow Pale Hue, Raw Sienna and Phthalo Green for the middleground and foreground. When you have completed the background and it is dry, you can paint the cottage using the following method:

Decide where you want to put the cottage and, starting with the roof, paint or draw two letter "V"s upside down. These are the eaves.

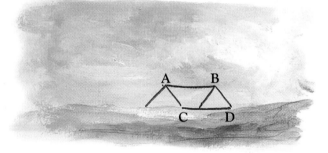

Then join point A to B and C to D.

Now draw the walls of the cottage. Don't make them too high, about half the height of the roof is fine.

Tip: Don't place cottage too low down in your picture. Break the horizon line with it.

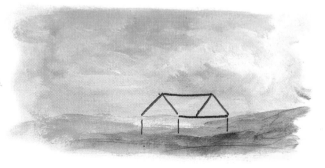

84

Then, using the medium brush, paint the roof with Raw Sienna and Titanium White.

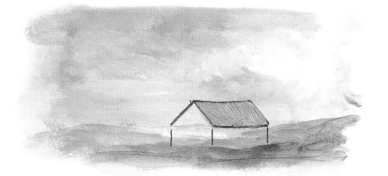

Paint the walls using Titanium White only. Now let's add in a door, a chimney and some windows. Don't be fussy. For the door and windows a simple number one will do. A big number one for the door and a smaller number one for the windows.

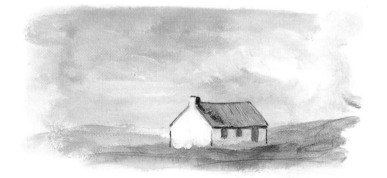

Finally paint a stack of turf and you are finished.

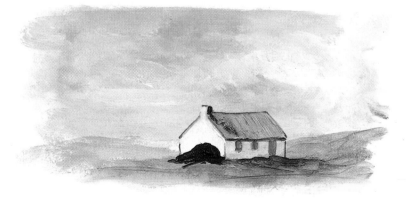

Bridges

Keeping with the idea of painting a background and simple shapes, to paint a bridge we start with the horizon line and then the arch, which is the letter "U" upside down.

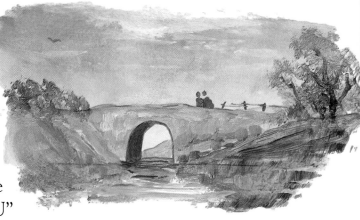

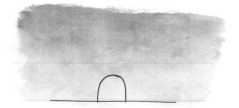

So using a pencil or brush, draw a horizon line and then draw or paint the letter "U" upside down.

Now, to give the impression of depth, make the "U" thicker on one side with a mix of Ultramarine and Burnt Umber.

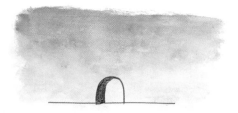

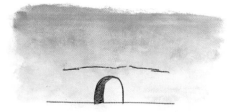

Next put a top on the bridge.

And that's all there is to it. Paint in the river bank and fill in the bridge using your own colours. Why not put in some carrot people?

By now I'm sure you realise there is nothing wrong with painting the same scene and making changes in it. In fact, it is one of the greatest exercises you can do. Not only are you learning to paint backgrounds, but you are also learning to compose pictures and this, without doubt, is a very important part of painting. If any silly person says your pictures look alike tell them that the old masters made sketches of figures, which they used in many paintings. Tell them that Monet painted hundreds of pictures of the lily pond in his garden and that he was also famous for his series of paintings of haystacks which are now in Chicago. What was good enough for Monet is good enough for us.

If you follow this advice you will improve rapidly and enjoy your hobby all the more.

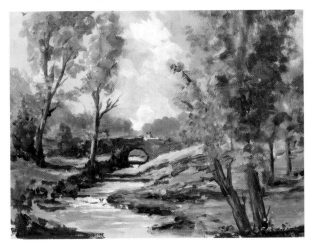

To Recap

1. Remember **Have Some More Fun**.
2. Paint the background first.
3. Don't paint the cottage or bridge too low. Paint them in the middleground so that they break the horizon line.
4. Don't make the walls of the cottage too high.
5. There is nothing wrong in painting the first lesson again and then putting in a cottage. Remember Monet.

13: Trees

Trees grow from the ground up and that is the best way to paint them. Start by painting the trunk from the ground and work upwards, then we add the branches. What we are doing is constructing the skeleton of the tree, we can add the leaves later.

Trees are not telegraph poles, and the trunks must be strong enough to withstand wind and storms. These are probably the most common faults in painting trees and there is a simple way to overcome them. Go out and look at trees. When you do you will be amazed by what you see as you will probably begin to really look at nature for the first time. You will notice that tree trunks are strong and that foliage, depending on the time of year, is not just green, but a mixture of many colours. Some of my students seemed to think that branches started forty feet up a tree, that is, until they really started looking at them.

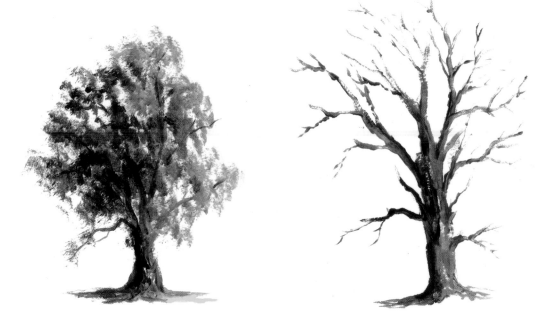

Trees are not telegraph poles

Painting trees is not only fun but a great way to learn how to make the forty shades of green. Here are some mixes using equal amounts of each colour, to help you paint foliage.

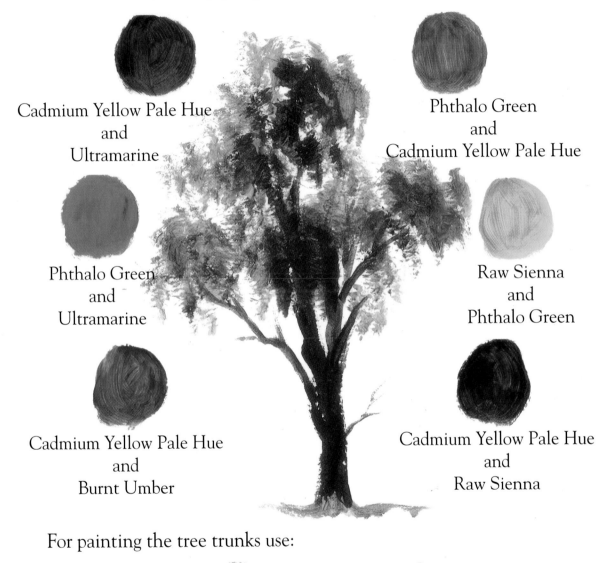

Cadmium Yellow Pale Hue
and
Ultramarine

Phthalo Green
and
Cadmium Yellow Pale Hue

Phthalo Green
and
Ultramarine

Raw Sienna
and
Phthalo Green

Cadmium Yellow Pale Hue
and
Burnt Umber

Cadmium Yellow Pale Hue
and
Raw Sienna

For painting the tree trunks use:

Raw Sienna
and
Burnt Umber

Burnt Umber
and
Ultramarine

There are many other mixtures you can use, these are just a few to get you started.

14: Water

Water is normally clear but reflects the colours that surround it, the sky, mountains, trees and land.

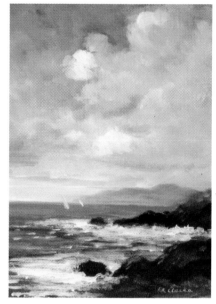

To give you an example, when you have a red sunset, the water will reflect the red. So remember, it is always important to look at nature. In fact one of the great joys when you start to paint is you will begin to look at and see nature's full beauty for the first time. I can't tell how many times a beginner has come to me and said, "Frank, I never realised there was so much colour in nature. I always believed water was blue and trees were green."

In fact be careful if you drive. My wife Peg does not let me drive when I am in my beloved West of Ireland as she says I don't look at the road, and she is right as usual.

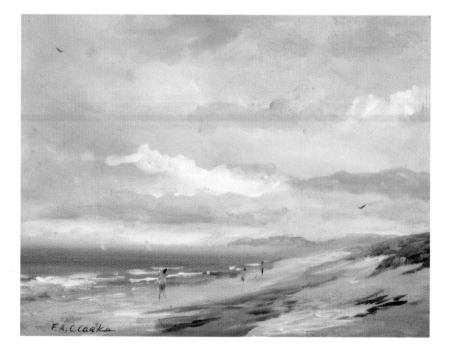

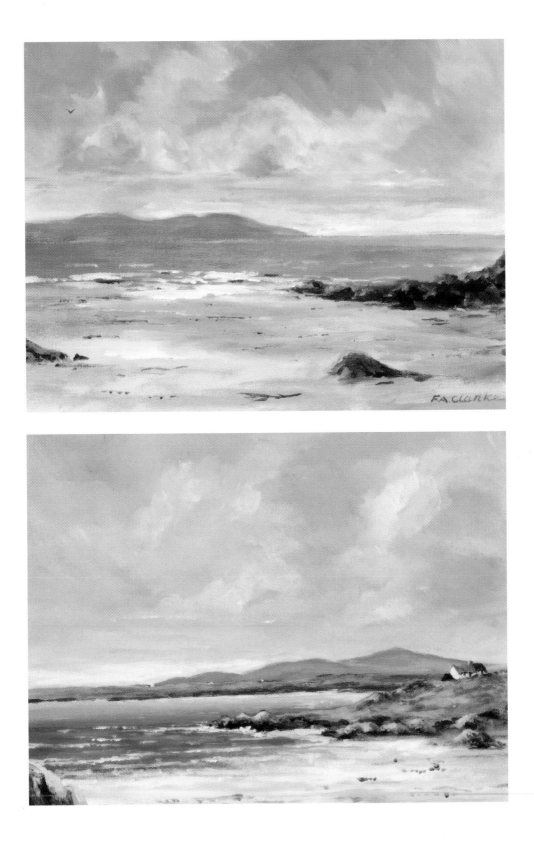

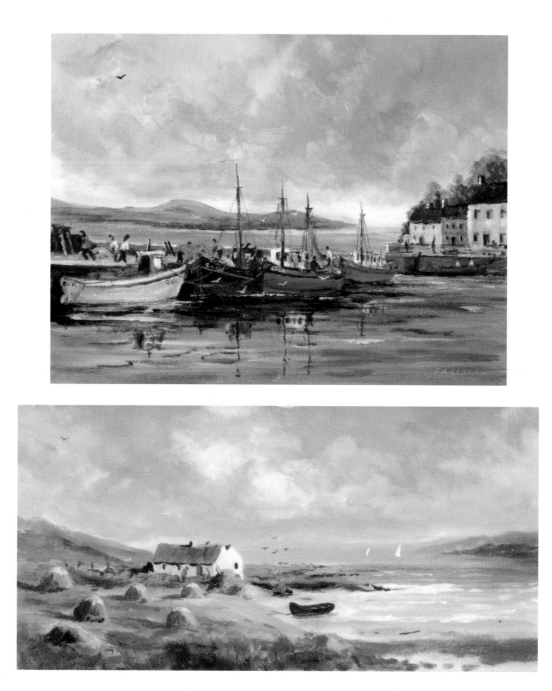

To Recap

1. Water reflects its surrounding colours.
2. Water reflects sunlight.
3. Don't drive and look at nature.

15: Skies

Now we come to my favourite part of any landscape painting, the sky. I am convinced if you get the sky right the rest of the picture will follow. One of the great advantages of acrylic paint is that it dries so quickly you can adjust the sky (that is not fiddling, is it?). But remember acrylic paint darkens when it dries so don't make your sky too dark.

Another point to remember is that the clouds look bigger at the top of the sky than at the bottom. I always say the big sausages (clouds) are at the top and the little sausages low down. This is because the horizon is further away.

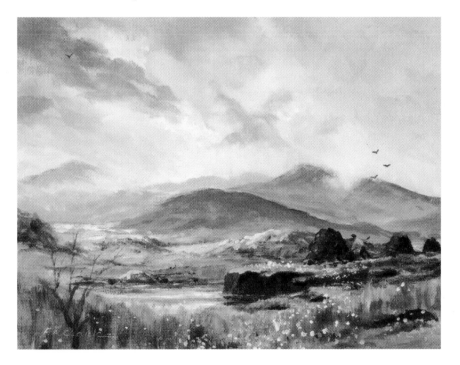

Next and I think more important, skies are not always blue. In fact most of the time they are anything but blue (which can be a pity when on holidays!). I am sure you have all heard of grey skies and red sunsets.

I hope by now you will have painted the first lesson, which is three colours only and you realise that Raw Sienna and Ultramarine skies can happen. A good exercise to help you paint is to look at reproductions of the impressionists, Van Gogh, Cezanne, Monet, etc. and you will see they used every colour in their skies.

You will notice that the skies are in harmony with the land which means using the same colour paint in the middleground and foreground as you do in the sky. Here are some examples of what I mean:

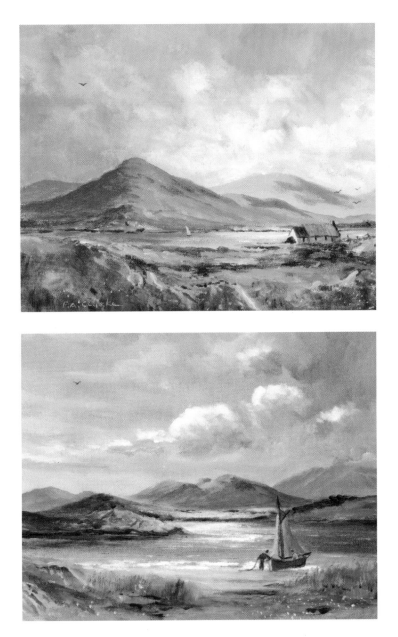

To Recap

1. Put the big sausages (clouds) at the top of your sky to give the impression of distance.
2. All skies are not blue.
3. Try painting a sky the same colour as the land.
4. A sky a day makes an artist. Practise painting skies.

16: Light and Shade

Light and shade means seeing where sunlight originates from and conveying it in your painting. Light and shade is what puts life into a painting but be careful, don't overdo it.

Once again I say, look at nature, see how light reflects on water and mountains and how it changes with the time of day and seasons of the year; but don't force light and shade into your picture, let it come naturally. It will with practice.

When you put shading into your painting be sure that light is coming from the same direction in the overall picture. There is only one sun in our solar system.

Shading your vase:

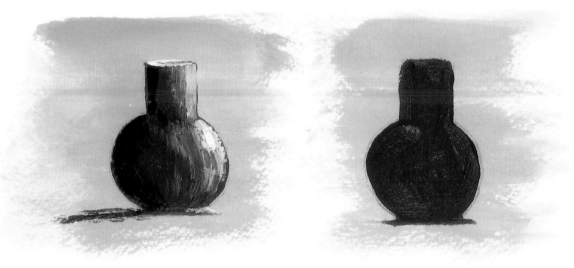

Shaded Vase **Unshaded Vase**

Note how the shadows of the trees all run in the same direction.

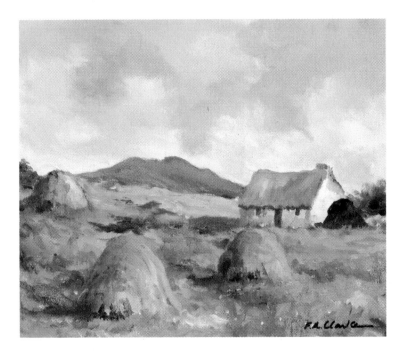

To Recap

1. Don't overdo light and shade.
2. Light comes from one direction.

17: Do's and Don'ts

Make sure the horizon line is straight.

Don't make distant mountains too big.

Don't make fences too straight.

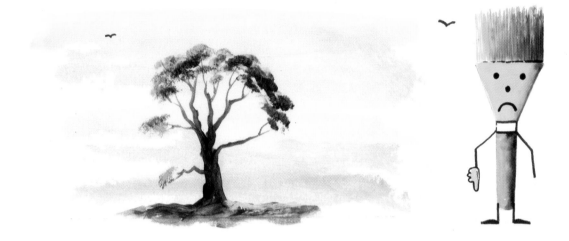

Don't put leaves on the outside of trees only.

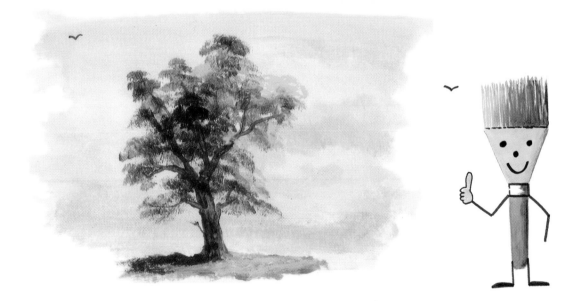

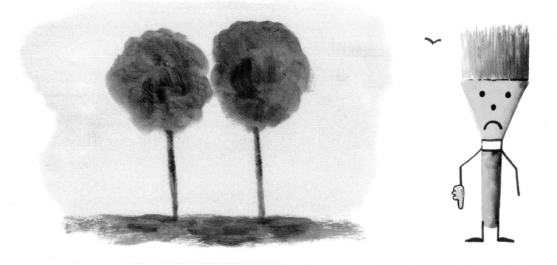

Don't make tree trunks too thin.

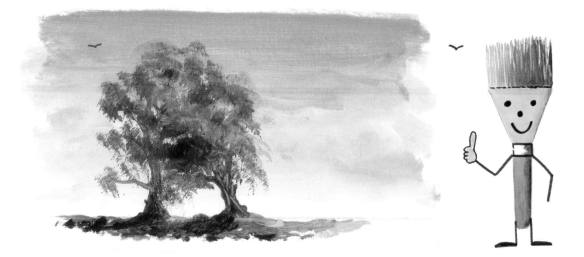

18: *Frame Your Pictures*

If there is one sure way to improve the look of a painting it is to frame it properly. This does not necessarily mean expensively. Although it is fair to say, I have seen many nice pictures ruined by a very cheap frame so I suppose a happy medium is best, not too expensive and not too cheap. After all you do want your picture displayed to its best advantage.

There are many types of frames suitable for acrylic paintings but as we are painting in an oil type mode I will stick to suggestions for that format.

Frames can be one piece of moulding or can be made of several frames joined together and I would say that generally the more sections the more expensive a frame becomes. This of course is because of the extra workmanship entailed in constructing the frame. For this reason I suggest that you stick to a single moulding but try to ensure it is at least 2" to 3" (5cm to 7.5cm) wide. Anything less in my opinion will not show your picture to its best advantage.

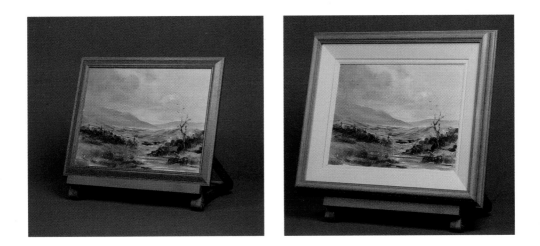

Tip: Keep a spare frame at home to try on your pictures.

19: Sketching

I have often heard it said that, "you have to be an architect to draw or sketch", - WRONG. As the word suggests, sketching is just making simple freehand outlines of what you are going to paint. Let me take you back to the letter "M" for mountains or the carrots for people. You can by now, if you have used the book correctly, sketch boats, cottages and draw a horizon line, so to say you can't sketch is wrong.

So having proved you can sketch, let's do it. The materials you need to sketch are a pencil, eraser and a sketch pad. However I have made many sketches on beer mats and other scraps of paper. All a sketch needs to be is a rough outline of a scene for further elaboration.

With the pencil, start by drawing the horizon line. This is your guide for every sketch. Using the **Have Some More Fun** method on page 24 as your model, draw the mountains on top of the horizon line. Now we have the mountains and the riverbank. Now draw the foreground.

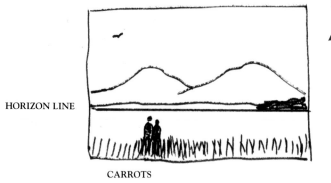

HORIZON LINE

CARROTS

DIRECTION OF LIGHT

This time, why not put in some carrot people, they will give your picture scale.

Don't forget the bird (my trade mark).

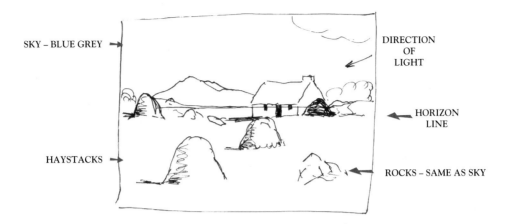

It is also a good idea to make notes of the colours you see and put them on your sketch to use later when painting your picture.

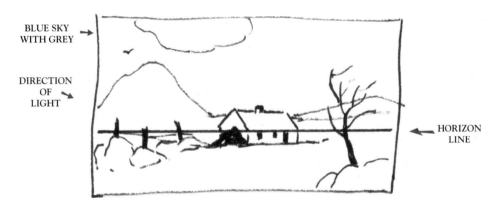

Tip: The aim should be to simplify the subject as much as possible before you start to paint it.

To Recap

1. Draw the horizon line first.
2. Keep sketches simple.
3. Take note of the colours.
4. Take a pencil, eraser and sketch pad with you when you go out. You never know what will catch your eye.

20: How to Paint from Photographs

There is nothing wrong in using photographs to aid you with your painting. As I have said many times the invention of the camera has been a great assistance to the artist. It allows us to make quick reference pictures of a scene we would like to paint and don't have time to sketch. I often take a photograph of a subject I would like to paint.

There is a belief held by some amateur and hobby painters that we should not use photographs to aid our painting. This of course is completely incorrect. Many professional artists use photos and why not? I will say use photos you take yourself, then its your composition. You will also become a better photographer, because you are composing pictures not just taking snaps.

Let's get on to the do's and don'ts of using photographs. First, simplify. It is not necessary to try to paint a mirror image of the photograph. Only use the main points of interest.

Second, remember the brush is mightier than the bulldozer, so don't forsake the best angle for your photograph because there is a telegraph pole in your way. Take the best photograph composition-wise and just leave out the telegraph pole when painting the picture. Often people look at my photographs and say, "Why did you take a photograph of that unsightly telegraph pole?" to which I reply, "What telegraph pole?"

The colour of your photographs can vary, depending on where you have the prints made. They can often be dull so don't try to copy the colours, use your own.

My best advice would be to think of your camera as your sketch book and only use the photographs as a reference. If a mountain does not fit into your painting move it. The painting is your interpretation of the scene.

To finish, anyone who tells you it is cheating to use photography as reference is only cheating themselves of a valuable asset.

A word of warning, when starting to paint, often well meaning friends who have heard you have taken up the hobby, will arrive with a photograph of their holiday in London, showing Buckingham Palace complete with the changing of the guard and ask you to paint it for them. My advice is sell them a picture you have already painted and tell them you are too busy to take on any commissions. Or better still let them start **Simply Painting** and then they can paint it themselves. The moral is to start using simple scenes and progress.

Following are some photographs to sketch and paint, until you take your own of course. Remember, **Have Some More Fun**.

Photograph

Sketch

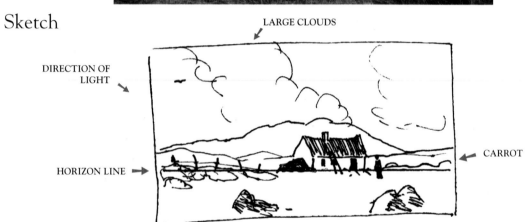

Painting

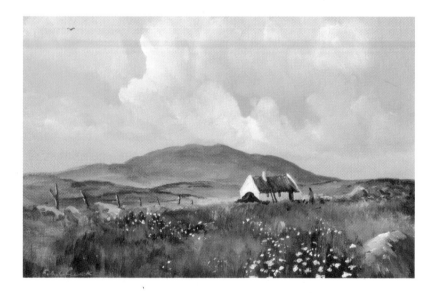

Photograph

Sketch

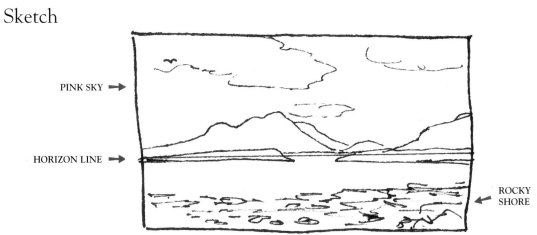

PINK SKY ➡

HORIZON LINE ➡

⬅ ROCKY SHORE

Painting

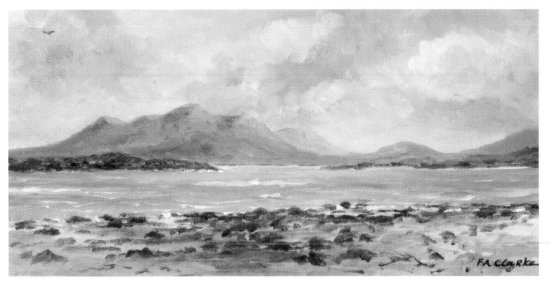

F.A. Clarke

To Recap

1. Use your camera as your sketchbook.

2. Keep your scenes simple.

3. Use photographs you have taken yourself.

4. Don't try to paint a mirror image of the photograph.

5 Remember you can move mountains with a paint brush.

6. Keep it simple

21: Painting Outdoors and Indoors

One of the great advantages of painting with acrylic paints is you can work both indoors and outdoors, weather permitting. Since your painting will dry very quickly, you don't have to worry about damaging your work in transit.

So let's talk first about painting outdoors. You need the following materials: paints, brushes, palette, easel, water, water container, old cloths and last, but by no means least, a fold-up seat. I find it a good idea to make a check list which I hang in my studio at home. I always refer to this list before I go out for a day's painting, as experience has taught me, there is nothing more annoying than to arrive at a destination to find I have left something at home.

When you arrive at your destination, select a subject and make a simple sketch of it. I hope you have read the chapter on sketching, if not, do so now. You can if you like, sketch directly onto your canvas board and then paint over it. I do this all the time. Remember you don't have to put every little detail into your picture, just the main points.

KEEP IT SIMPLE.

A good way to help you compose your picture is to make a view frame. Here is how you do it. You may have seen artists holding their hands out in front of them like this, and wondered what they were doing.

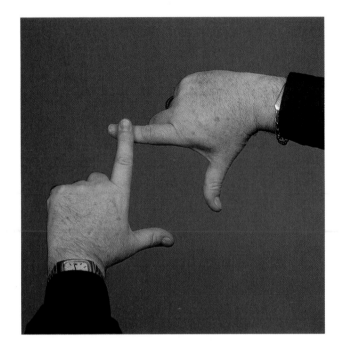

They were in fact creating a frame with their hands so they could select the scene they wanted to paint by blocking out the surrounding area. If you don't do this it is very difficult to select where the picture starts and finishes.

Now we come to indoor painting which can have many advantages over painting outdoors. First you can paint in any weather and at any time of the day or night you feel the urge. All you need is space and good light. I use the term good light because you don't want to try to paint in bad light - it makes it impossible to select colours. If you are lucky enough to have a spare room, so much the better, you can call it your studio. This will allow you to participate in your new hobby without interference.

23: Colour Chart

A colour chart can be a great help to the budding artist. The purpose of a colour chart is to give you your own physical record, so you will be able to see at a glance, the mix of any two colours.

You have by now I hope, painted at least three pictures. One of the problems you may have encountered is that since you are not sure what two colours you mix to get a third colour, you may have ended up with that well known colour - MUD. By making your own colour chart you will learn how to mix colours.

First let's start by saying there are three primary colours - red, blue and yellow. In theory all other colours can be obtained by mixing these three. However enough about theory, I have made it my business to stay as far away from the theory of painting as possible. It is my firm belief that painting as a hobby requires painting first and theory second. For that reason I have left the colour chart until now. In one of the classes I attended I spent the first four lessons making a colour chart without ever getting to paint a picture. This I think is the wrong way around.

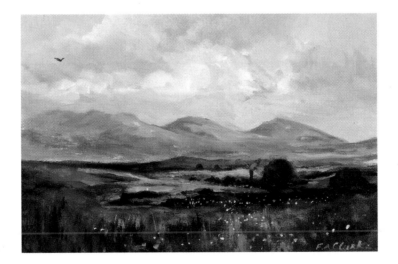

So how do we make our own colour chart?

For example using Ultramarine and Cadmium Yellow Pale Hue, on your palette mix more Ultramarine than Cadmium Yellow Pale Hue and paint Box A.

Next using more Cadmium Yellow Pale Hue than Ultramarine, paint Box B.

Now on your palette add Titanium White to the mix you used for Box A and paint Box C.
Finally add Titanium White to the mix you used for Box B and paint Box D.

Ultramarine and Cadmium Yellow Pale Hue

Keep doing this until all the colours on the palette are used. You need not complete all the exercise at one sitting but build it up over a period of time. You can refer to your colour chart any time you need to know what colours you mix to get a required shade. You won't have to mess around trying to find a particular colour.

In the meantime you can use my colour chart as a guide for matching your colours until you make your own.

Permanent Rose and Cadmium Yellow Pale Hue

A B C D

Phthalo Green and Cadmium Yellow Pale Hue

A B C D

Raw Sienna and Cadmium Yellow Pale Hue

A B C D

Burnt Umber and Cadmium Yellow Pale Hue

A B C D

Burnt Umber and Vermilion Hue

A B C D

Vermilion Hue and Cadmium Yellow Pale Hue

A B C D

Permanent Rose and Ultramarine

A B C D

Phthalo Green and Ultramarine

A B C D

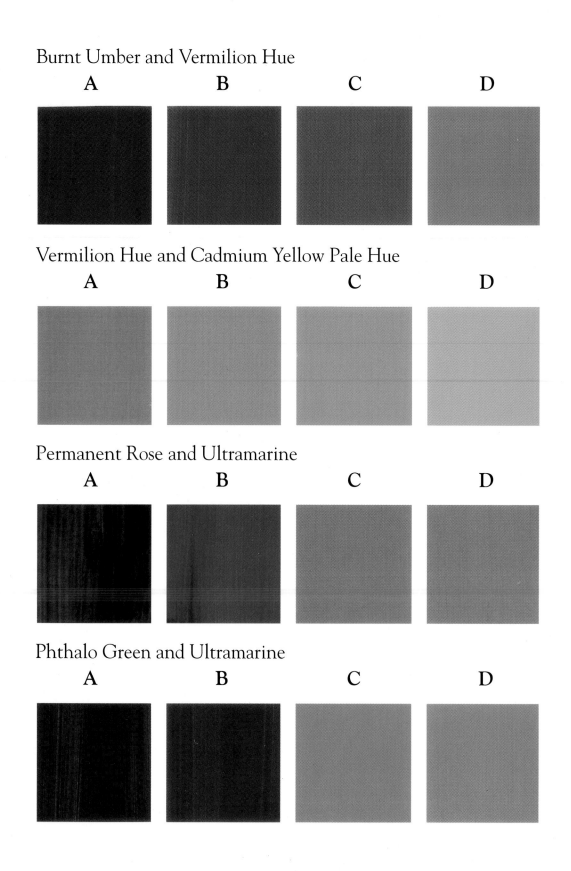

Raw Sienna and Ultramarine

A B C D

Burnt Umber and Ultramarine

A B C D

Vermilion Hue and Ultramarine

A B C D

Phthalo Green and Permanent Rose

A B C D

Raw Sienna and Permanent Rose

| A | B | C | D |

Burnt Umber and Permanent Rose

| A | B | C | D |

Vermilion Hue and Permanent Rose

| A | B | C | D |

Raw Sienna and Phthalo Green

| A | B | C | D |

Burnt Umber and Phthalo Green

A B C D

Vermilion Hue and Phthalo Green

A B C D

Burnt Umber and Raw Sienna

A B C D

Vermilion Hue and Raw Sienna

A B C D

23: Points to Remember

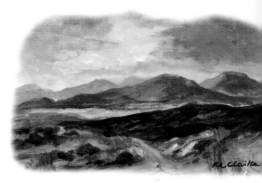

- Keep your picture simple. The aim should be to simplify the subject as much as possible before you start to paint.

- Don't be mean with paint, always mix enough paint as it can be difficult to repeat the exact mixture.

- Use your large brush as much as possible. Only use your small brush to put in final details.

- Don't fiddle. Stop when you start looking for something to do with your picture - its finished.

- Practise mixing colours.

- Keep a spare frame to try on your picture.

- You paint acrylics from dark to light. This means paint dark colours first and then paint light colours.

- Keep referring to the subject you are painting.

- Try to finish one picture before starting another.

- Make it a habit to always replace the caps on your paint.

- Don't forget to keep your brushes in water when painting and to wash them well when finished.

- Trees are not just green, they will change colour according to the season.

- A camera can be your best friend, if used wisely.

- Water reflects its surroundings.

- You can paint your own still life with articles from around the house?

- Sketching is easy and fun, don't be afraid of it.

- Be sure that you at least start your colour chart, you don't have to complete it at one sitting.

- Remember the **Simply Painting** motto - ***Have Some More Fun.***

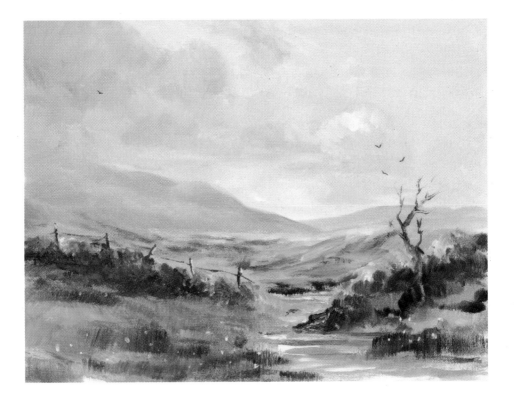

24: Questions and Answers

Q. Can I mix oil paint and acrylic paint together?

A. No.

Q. Can I paint oil paints over acrylic paints?

A. Yes, but not the other way around.

Q. What can I do if I forget to wash my brushes after use and they get hard?

A. It may be possible to clean hardened brushes using a brush cleaner but this can damage your brushes, so make it a habit to wash them with soap and water when you finish painting.

Q. Can I use a palette knife with acrylic paints?

A. Yes, in the same way as with oil paints.

Q. Can I mix one brand of acrylic paints with another?

A. Yes, but it is better to stick to one brand as shades can differ between brands.

Q. Is it possible to slow down the drying process?

A. Yes, there is an acrylic retarder you can purchase which will slow down the drying process.

Q. Can I use acrylic paints as watercolours?

A. Yes, just use extra water in the same way as you would when mixing watercolours. I will tell you more in the next book on acrylics.

Q. When dry, can acrylic paint be removed?

A. The quick answer is no, but you can paint over it.

Q. What can I paint acrylic paint on?

A. This is where acrylic shines, you can use stretched canvas, canvas boards, paper, copper, glass, leather, parchment, marble and slate, so the easy answer is almost any surface that is grease and dust free.

Q. How can I keep my paint moist over a long period?

A. I will answer this question with a little gift in the next chapter.

Q. What other aids are available for painting with acrylics?

A. There are many other aids available. Here are a few:

Acrylic Retarder comes in gel or liquid form and is used to slow down the drying process of the paints.

Acrylic Gloss Medium, if mixed with your colours while painting, gives an extra shine to the them when they dry.

Acrylic Matt Medium is used in the same way as gloss medium and gives a matt or eggshell finish. Both gloss and matt mediums can be used instead of water to increase the flow of paint.

Acrylic Modelling or Texture Paste is available in glass jars or plastic containers and has a stiff consistency. It is used for building up areas of paint where extra thickness (impasto) is required e.g. rocks.

Acrylic Gesso Primer is a white paint used to prepare canvas that has not been primed (undercoated). Don't worry, your canvas boards have already been primed.

Acrylic Gloss Varnish is used to protect your painting from dirt and give the picture a shine when it dries.

25: A Little Gift to Finish

Acrylic paint dries very quickly, which is great for painting, but can cause a problem when you find your paint is drying too quickly on your palette.

A stay wet palette is a means of keeping your paint soft for longer periods. Stay wet palettes can be purchased, but I am going to show you how to make your own. Call it my little gift to you.

This is what you need:

A **Simply Painting Acrylic Palette** or a large white plate or tray.

One sheet of blotting paper or paper towel.

One sheet of greaseproof paper cut to size 14" x 10" (35.5cm x 24.5cm).

Put the blotting paper or paper towel on your palette. Now wet it just enough to dampen it.

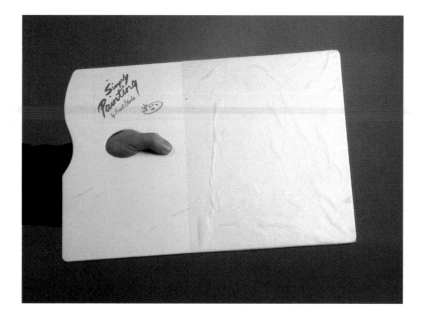

Then lay the greaseproof paper over the blotting paper.

That's all there is to it. You now have your own stay wet palette.

Put your paint onto the greaseproof paper and use it in the same way you use your palette.

If you want to keep your paints moist overnight, put a lid or cover over the palette. If not, when finished painting, throw away the greaseproof paper with the remaining paint on it. The next time you want to use your palette, wet the blotting paper (or paper towel) and put a new piece of greaseproof paper on it and you are ready to paint.

The Last Word

Dear Reader,

Or should I now say fellow hobbyist. If you followed this book without skipping (I know it's hard to resist a quick look at the end), you are by now hooked on this wonderful hobby. You will also have realised that painting is easy.

I hope you tried the lessons and have the results hanging in your home. This great hobby has many assets and it is never too late to start. Many don't start until their seventies or eighties. Did you ever notice the great age attained by artists? I am convinced the reason is that painting keeps our brains alive and our hearts young because there is no retirement age from painting.

To finish, I hope I have removed some of the misleading nonsense which has wrongly convinced many budding artists that painting is a complex art only possible for the chosen few.

I feel millions of people have been robbed of the benefits of this wonderful hobby by having their inborn artistic talents stifled at an early age. After all, we could all paint and draw when we were children. Unfortunately we lose that confidence, that's all it is, as we grow older. I'm sure you have now regained it.

I hope you have enjoyed **Simply Painting** and will continue to paint and **Have Some More Fun**. Till we meet again, goodbye from Mr. Brush and myself.

Remember **H-S-M-F** *Have Some More Fun*

Frank Clarke

For information regarding Frank Clarke's painting classes or the materials used in this book contact:

Simply Painting
P.O. Box 3312
Dublin 6W
Ireland

Please enclose a stamped addressed envelope
if replying from within Ireland
or an
International Reply Coupon
if replying from outside Ireland

A *Simply Painting Kit and Video are available for painting in Acrylics*

Simply Painting products available for painting in Watercolours